DRAW
MANGA FACES
for Expressive Characters

Draw Manga Faces for Expressive Characters
First English edition published in 2014 by IMPACT, an imprint of F+W Media, Inc.,
10151 Carver Road, Suite 200, Blue Ash, Ohio 45242. (800) 289-0963. First Edition.

www.fwmedia.com

21 20 19 18 17 8 7 6 5

Original Japanese edition published by Seibundo Shinkosha Publishing Co. Ltd., Japan
CHARACTER NO YUTAKANA KANJO HYOGEN NO KAKIKATA
Copyright © 2011 Color Ltd. All rights reserved.

This English edition is published by arrangement with
Seibundo Shinkosha Publishing Co. Ltd., through Tuttle-Mori Agency, Inc., Tokyo
English language rights, translation & production by World Book Media, LLC
Email: info@worldbookmedia.com

Distributed in Canada by Fraser Direct
100 Armstrong Avenue
Georgetown, ON, Canada L7G 5S4
Tel: (905) 877-4411

Distributed in the U.K. and Europe by F&W MEDIA INTERNATIONAL
Brunel House, Newton Abbot, Devon, TQ12 4PU, England
Tel: (+44) 1626 323200, Fax: (+44) 1626 323319
Email: enquiries@fwmedia.com

Distributed in Australia by Capricorn Link
P.O. Box 704, S. Windsor NSW, 2756 Australia
Tel: (02) 4560 1600, Fax: (02) 4577 5288
E-mail: books@capricornlink.com.au

ISBN-13: 978-1-4403-3728-4

Manufactured in China

DRAW
MANGA FACES
for Expressive Characters

Learn to Draw More Than 900 Faces

Aya Hosoi

A Note from the Author

Drawing faces is one of the most challenging aspects of manga. For starters, there are so many details to capture in such a limited amount of space. Plus, there are many subtle nuances to facial expressions—the way you angle the eyebrows can be the difference between laughing and crying.

In addition to accurately portraying a specific emotion, you must make sure that the expression is in line with your character's personality, age and gender. This task becomes even more complicated when drawing stylized cartoon characters.

Although it may seem intimidating, there is a secret to mastering facial expressions: Practice. Challenge yourself to attempt one facial expression per day. Start off by copying the examples included in this book, then push yourself to make sketches in your own style.

There's no need to be concerned with perfection while you work. Stop thinking and start drawing. Remember, the best drawings are the ones that are uniquely yours!

—Aya Hosoi

Contents

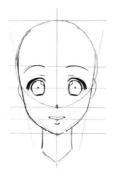

CHAPTER 1

Drawing Basics for Faces and Expressions 9

CHAPTER 2

Basic Characters 19

CHAPTER 5
Negative Facial Expressions 93

CHAPTER 6
Color Illustration 151

Chapter 1

Drawing Basics for Faces and Expressions

In order to draw expressions, it helps to first understand the basic structure of the face and how features are positioned in relationship to each other. In this chapter, we'll learn to draw the face from a variety of angles.

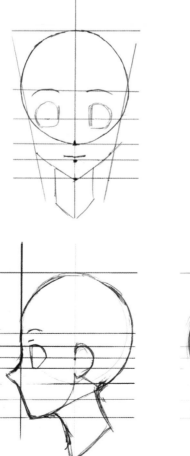

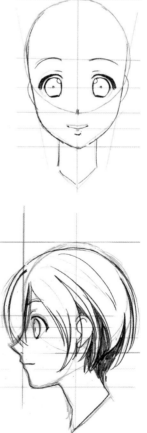

1.1 *Frontal View*

Let's start with a basic frontal view of a face. We'll use a simple drawing method to learn about proportion and feature placement. Whether you are drawing a realistic portrait or a stylized cartoon, the same principles of facial structure apply.

Before you start drawing, take a minute to imagine your characters and consider their state of mind. If you just rush in, you might lose sight of why you're drawing them in the first place! Try jotting down a few notes in the margins about where they're going, what they're doing and how they're looking and feeling: "Middle school student," "on the way to school," "throwing their hands in the air," "school uniform," "flustered." These notes to yourself can help you clarify your characters and bring them to life on the page.

01 First, draw a circle. This will be your base for all faces. The top of this circle corresponds to the top of the head, and the bottom to the bottom of the nose.

02 Draw two perpendicular guidelines meeting in the center of your circle in a cross. The horizontal line marks the eyebrows while the vertical divides the face in two equal halves.

03 Now fill in more lines to mark the main features. Divide the distance between the eyebrows and bottom of the nose in half to find the center of the eyes (the pupils). Imagine the size of your character's eyes and rough in their top and bottom lids. The chin's placement is much more flexible depending on your character. Drawing the chin the same distance down from the nose as the distance between the eyebrows and nose is a good rule of thumb. Draw the lip line halfway between the nose and chin.

04 Find the facial features in your sketch, and draw the basic outline of the face. This is your chance to determine how wide or angled the jaw will be. Draw symmetrical diagonal lines from the eye line to the mouth line to form the cheeks. Don't forget the ears: Mark them right where the circle meets the cheek lines.

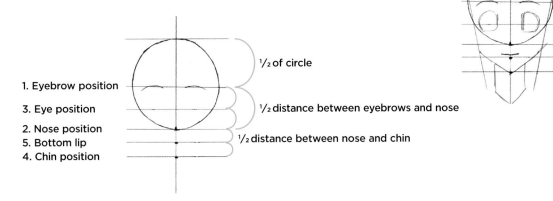

1. Eyebrow position

3. Eye position

2. Nose position
5. Bottom lip
4. Chin position

½ of circle

½ distance between eyebrows and nose

½ distance between nose and chin

05 Rough in the rest of the features.

06 Add hair and finish your drawing!

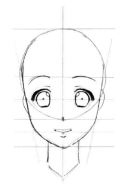

Facial proportions can say a lot about a character. See how many different characters you can make!

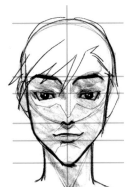

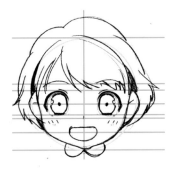

When drawing cartoons, it helps to add lines for the top and bottom of the eyes, since these characters often have large eyes.

Now that we've shown how to draw a face from the front, let's draw the profile. You've already done the work of measuring out the facial features, so it's easy!

01 Start with another circle.

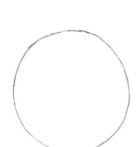

02 Bisect the circle with two perpendicular guidelines. The top of the circle marks the top of the head, and the bottom marks the bottom of the nose, same as a face from the front. Draw a vertical line down the side of the circle you want your profile to face.

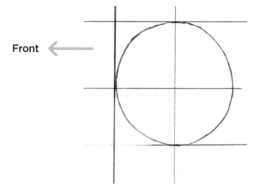

Front ←

03 Mark out the same proportional lines as before.

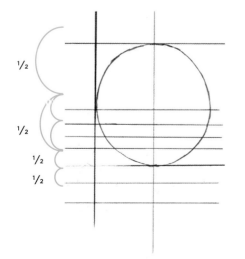

½

½

½

½

04 The chin typically sits directly below the eye, but you can adjust its position to fit your personal style. Draw a line to connect the bottom of the nose to the chin.

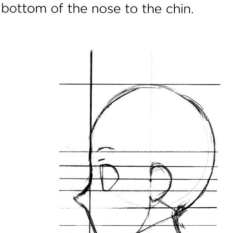

05 Rough in the rest of the face and hair and bring your profile to life. It is important to draw the eye behind the eyebrow to show 3-D depth.

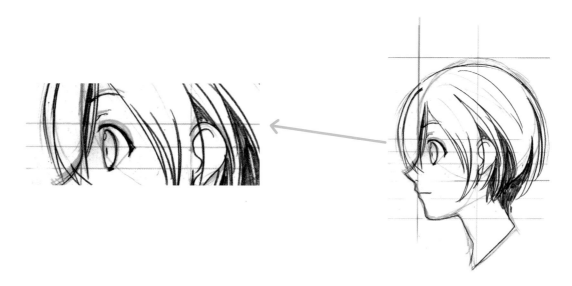

06 Finish the profile.

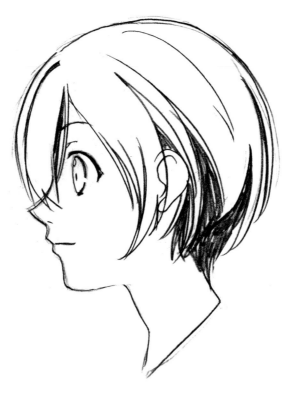

Do your frontal and profile faces match up? Once you turn a face to the side, you might realize that "Oh, the chin is too long!" or "The nose is much lower than I thought." That's why it's important to be aware of the 3-D form of your character's face when you draw it from the front.

Three-Quarter Angle

For a classic three-quarter angle, we need to find the right position for the eyes and ears. Keep the three-dimensional shape of the cheek and jaw in mind as you draw.

01 Draw a circle again.

02 Pick a centerline pointing in the direction your character will face, but note that since this is a three-quarter angle, that line won't be in the center of the circle; it will be closer to one side. Next, find the center of that line with a cross, and mark the top of the circle as the top of the head and the bottom as the bottom of the nose. Add a line parallel to the central line for the jawline.

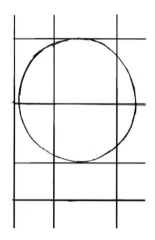

03 Find the positions for each facial feature. If you're drawing the same character as with the frontal and profile views, the proportions will stay the same too. Be careful to match the positions or you'll end up with quite a different face!

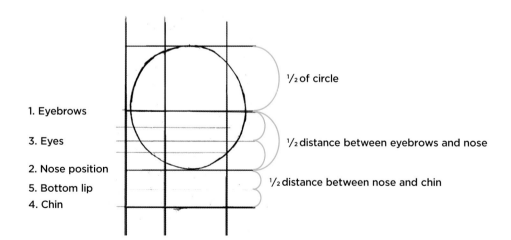

1. Eyebrows

3. Eyes

2. Nose position
5. Bottom lip
4. Chin

½ of circle

½ distance between eyebrows and nose

½ distance between nose and chin

05 Next, let's rough in the basic features.

06 Give your character some hair and don't forget the details.

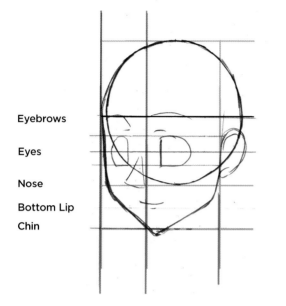

Eyebrows

Eyes

Nose

Bottom Lip

Chin

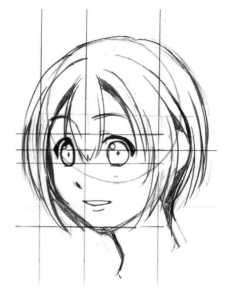

07 Finish your character!

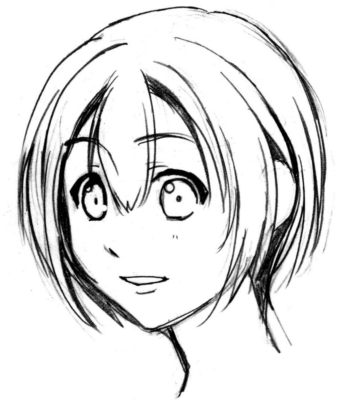

(1.4) *High and Low Angles*

Now we'll learn how to draw the face from both a worm's eye view and a bird's-eye view.

Low Angle/Worm's Eye View

01 Draw a circle first.

02 Draw two perpendicular lines that show the direction of the face.

03 Find the lines for each feature's position along the axis.

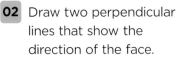

04 Rough in the facial features.

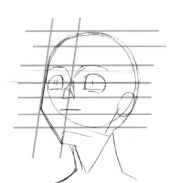

05 Add remaining details.

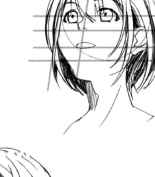

TIP: If this angle is difficult, imagine your character's face as a box to help visualize its depth.

06 Fix up your lines and finish up the low angle view!

High Angle/Bird's-Eye View

01 Start with a circle.

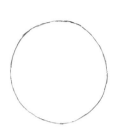

02 Draw a cross tilted downward.

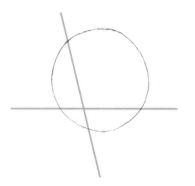

03 Add in the facial features along your perpendicular lines.

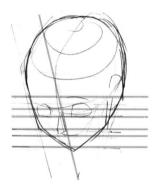

04 Detail the face and hair.

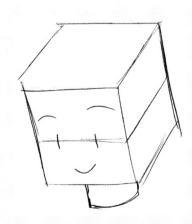

05 Fix the lines and finish.

TIP: High angle drawings conceal the jawline and show off the roundness of the skull. In contrast, low angle drawings hide the top of the head while revealing the underside of the jaw.

Circle Structures

Once you're comfortable with the dimensions of the face, try breaking the head down into two circles. With this method you can design well-balanced faces of all kinds, shapes and sizes. See how many different characters you can draw.

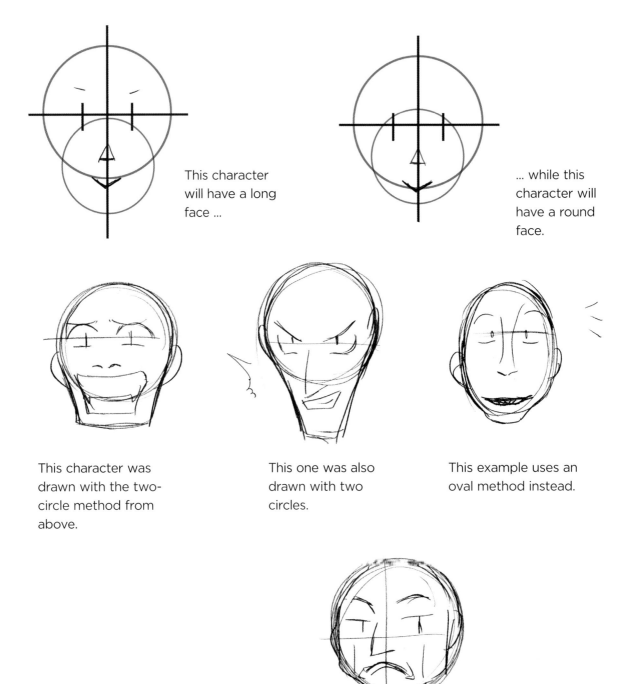

This character will have a long face ...

... while this character will have a round face.

This character was drawn with the two-circle method from above.

This one was also drawn with two circles.

This example uses an oval method instead.

This character was drawn with just one big circle.

Chapter 2

Basic Characters

Every detail of a character's body and face communicates information about their personality and mood. We'll start by looking at how gender and age will influence how you draw each of your characters' expressions and emotions.

Practice the tips and techniques in this chapter to master drawing all types of people—male or female, old and young.

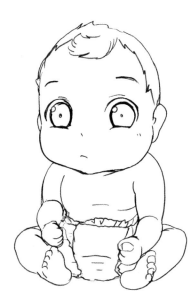

Boy (10-12 years old)

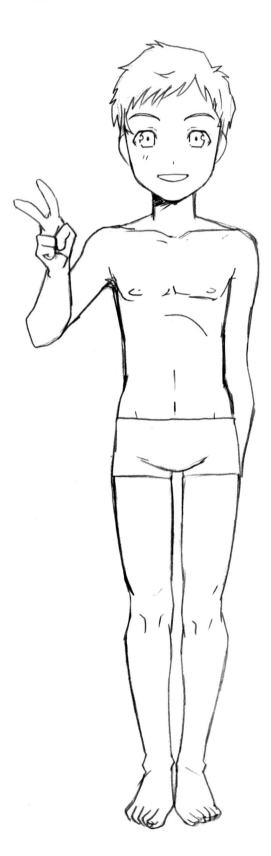

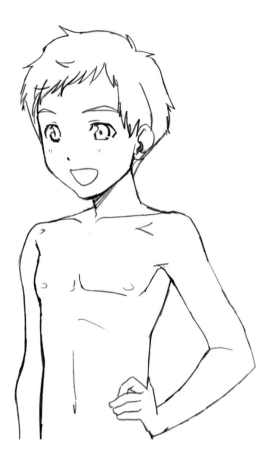

Let's start with drawing a typical male kid character. It's all about proportion: Young bodies will often have narrow shoulders and short, thin arms and legs. Bring your character's eyes and nose closer to make his face look more childish. When it comes to facial expressions, try round and soft shapes rather than hard angles. Think movement and energy as you draw your young character.

Smiling

Close his eyes, lift his eyebrows and show some teeth.

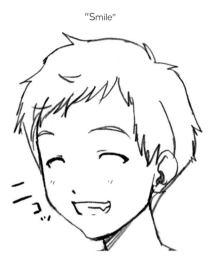

Confused

Give him a small mouth, raised eyebrows and wide open eyes.

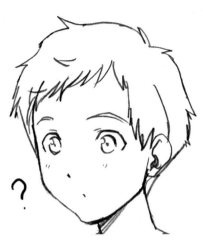

Crying

"Sniffle"

Twist his mouth and eyebrows up with emotion.

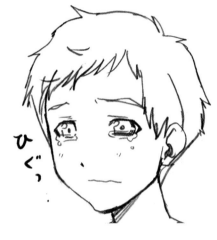

Angry

"Really mad"

Point his eyebrows down toward his nose and let him shout.

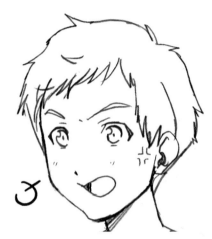

Compassionate

"Aww"

Tilt his eyes and eyebrows up very slightly for a quiet look.

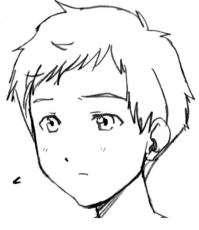

Laughing

"Ha ha ha"

Open his mouth wide and try a wink!

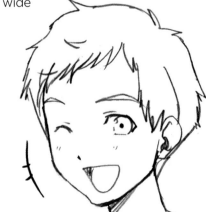

Teen Boy (14-16 years old)

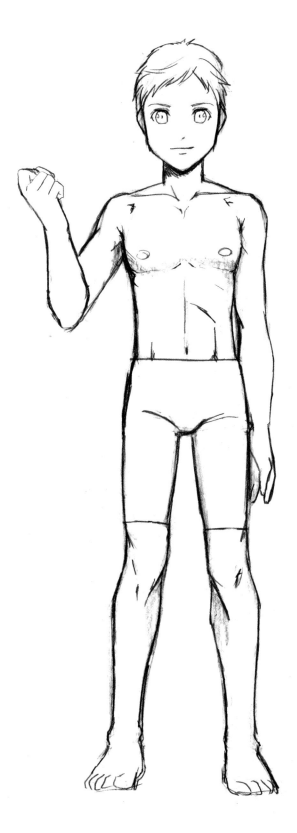

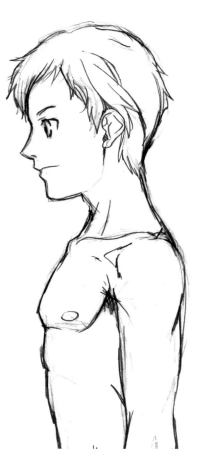

This is the age where our boy's body grows taller before his muscles catch up! Our boy character is growing noticeably now, so draw him 5 to 5.5 heads tall. His upper body widens, especially his shoulders, and his whole body gets more angular. Draw his head smaller and more ın balance with his body.

Normal

This is our teen at rest without any particular emotion. Use his pupils to show the direction of his gaze.

Smiling

"Smile"

Draw his closed eyes curved upward for a happy, pleasant look.

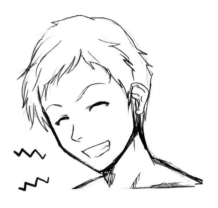

Crying

"Sob"

Show his emotion and frustration by clenching his teeth.

Devious

Convey his impish spirit with a toothy smile.

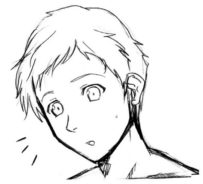

Confused

This expression has matured a little compared to the young boy's confused face.

Exasperated

"Sigh"

Curve his closed eyes downward and furrow his lifted eyebrows a little. Try a drop of sweat too.

Complaining

"No way!"

"Oh, give me a break!" Really furrow those eyebrows and open up his eyes. Use sound effects to help indicate his exact mood.

2.3 *Young Man* (18–21 years old)

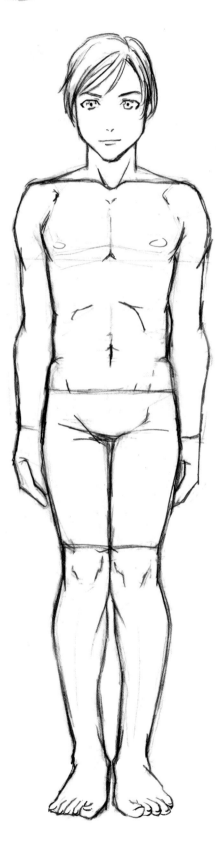

Now our character's body is fully grown, right down to the skeleton. He's about 6 to 6.5 heads tall and his face has taken on adult proportions. Make his jawline sharper and his nose more defined. To give him a more mature look, broaden his neck and shoulders and add muscular definition to his entire body. It's useful to reference an adult skeleton as you sketch.

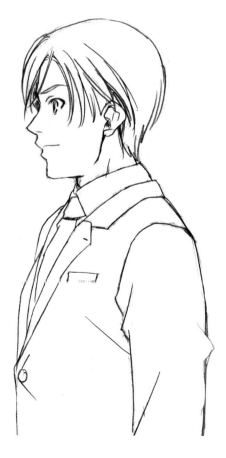

Normal

Keep in mind that his eyes are set deeper into his face than when he was a young boy.

Thinking

His mouth shape can give an idea of what's going on in his head.

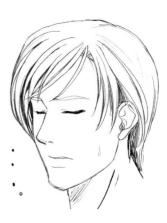

Crying

Lower his eyelids and show tears on the edges of his eyes and eyelashes.

Happy

Show joy by opening his mouth up wide. He's so happy, he's singing!

Ashamed

Keep his eyes directed away and to the side. Furrow his eyebrows slightly too.

Smiling

For a gentle, easy look, let his mouth hang open a bit.

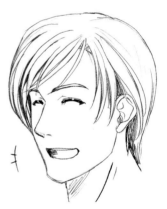

Scolding

Open his eyes up wide and angle those brows. Show his teeth if he's really getting worked up.

Surprised

"What?!" Keep his face open and his eyes wide.

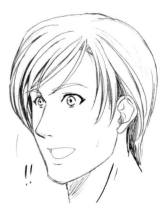

Middle-Aged Man

(40-50 years old)

Our character is still slender and stands about 6 to 6.5 heads high. We can now see his body begin to decline. Gravity starts to make its mark on his body, as his skin begins to loosen, his belly softens and the muscles of his legs get skinnier. As for his face, pay attention to how the skin around his eyes droops and wrinkles, and how his cheeks hollow out. Convey his age in the shape of his body before drawing details like wrinkles.

Smiling

Focus on his eyes and how the skin around them changes with his expression.

Sad

For a lonely face, tilt his eyebrows up and soften his eyes.

Upset

Turn the sides of his mouth down and show the emotion in his wide eyes.

Calculating

Make strong eye contact as he silently judges you!

Thinking

Close his eyes and play with the wrinkles above and below them to indicate his mental state.

Angry

When he's shaking with rage, open his eyes up wide, furrow those brows and clench his teeth.

Laughing

Draw the skin moving around his mouth.

Elderly Man (70-80 years old)

As your character leaves middle age, the aging process accelerates. You can show this by first reducing his stature to about 5 to 6 heads high. His eyes will sink deeper into their sockets, and his eyebrows follow his loosening skin. As for the lips, they'll grow thinner and flatter (and if your character loses his teeth, you can show the changing shape of his mouth with wrinkles). This particular character's still in good health, but even so, his back has curved and his legs have begun to bow outwards. Overall, his muscles have shrunk with age and his excess skin shows the pull of gravity.

Normal

A typical elderly face at rest. Draw his skull first, and then draw the muscle and skin of his face hanging from the bone structure.

Understanding

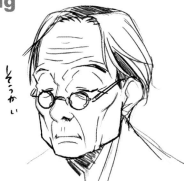

"Is that right?"

When he closes his eyes, his eyebrows and the skin around them move too. Tilt his eyes and brows down and outward.

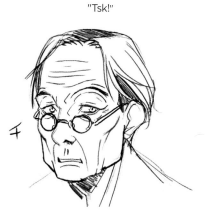

Smiling

"Heh heh heh"

His face will move and stretch a lot! Draw the skin wrinkling around the corners of his eyes and mouth.

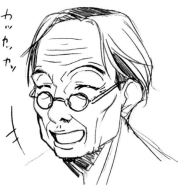

Devious

"Tsk!"

You can express guilt by drawing him looking to the side.

Listening

Show him watching closely and kindly with a closed mouth.

Crying

"I see ..."

Draw his eyes closed and bleary with tears right at their edges.

Shocked

"What did you say?!" Open his eyes and mouth up with surprise and let his eyebrows and skin follow with wrinkles.

Girl (10-12 years old)

This typical young girl character stands about 4.5 to 5 heads high and is cute as a button. Just like our young boy character, this girl has narrow shoulders with short arms and legs. Her body is just starting to grow and change, so her shoulders and waist will be rounder than the boy's. You can draw her eyes and nose close together for a more childish face too.

Normal

Keep her eyes and mouth big and her expression bright.

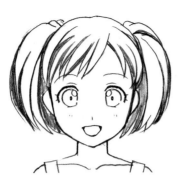

Thinking

Now she's imagining something fun. Let her mouth hang open a little.

Anxious

Tilt her mouth to the side and furrow her brows.

Crying

Draw downcast eyes full of tears and furrow her brows.

Smiling

Think curves! Bring her eyebrows and closed eyes up and open her mouth up wide.

Angry

Bring her eyebrows down firmly, give her big powerful eyes and show her mouth moving.

Shocked

Open her eyes up wide and shrink her irises and pupils.

Uncomfortable

Flatten her eyebrows and show her biting her lower lip.

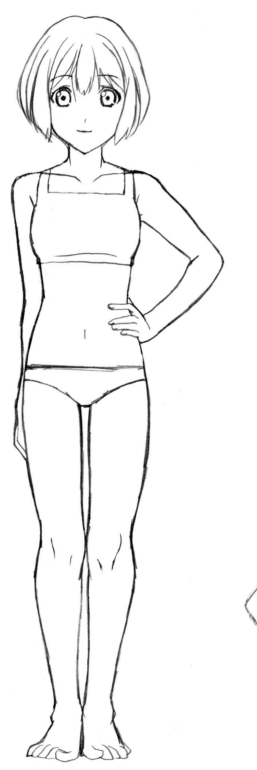

Now she's an adventurous teen! Draw her standing about 5 to 6 heads high. She's still getting taller and her face has lengthened, so balance out her features. Her chest and waist are growing rounder, and her muscles are developing too.

Normal

Our teen at rest. Her mouth is just a simple line.

Smiling

Bring her eyebrows up and close her eyes for a big beaming smile. Show the downward movement of her jaw.

Thinking

Change her eyebrows and pupils from her normal expression to suggest her inner mental state. What's she thinking about?

Satisfied

When she's in a silly mood, give her a kitty mouth. Lines on her cheeks can show her skin flushing with happiness.

"Mmm"

Angry

Furrow those brows and open her eyes wide. Show her speaking with an open, moving mouth.

"What?!"

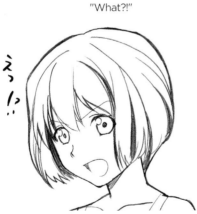

Shocked

Use her whole body to show her surprise. Widen her eyes and raise her hands to her mouth.

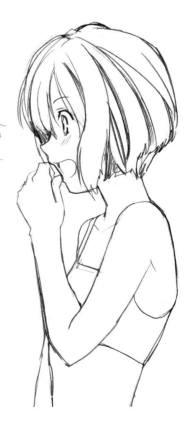

Crying

This time, she's flushed with sadness. Express subtle emotions with her closed mouth.

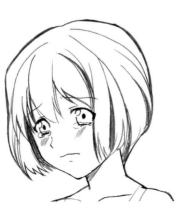

(2.8) *Young Woman* (18-21 years old)

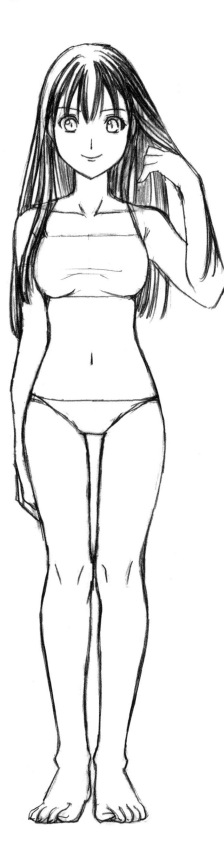

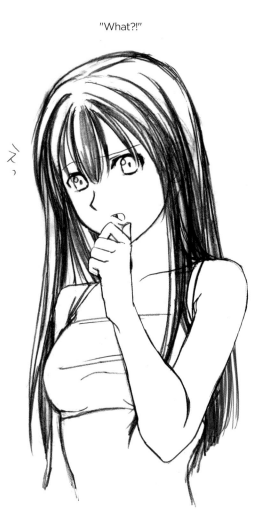

"What?!"

She's grown to an adult now, so try drawing her about 5.5 to 6.5 heads tall. Her muscular and skeletal systems are fully formed, and she looks quite different from her 10-year-old self. To give her a mature look, lengthen her legs, arms and neck. Her breasts have rounded and her hips have widened. Pay attention to how the muscles in her thighs and waist have strengthened too— reference a skeleton as you draw!

Normal

A sharp upwards tilt to her eyes can say a lot about her personality.

Crying

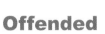

Show her emotion in the slackness of her face. Let her lids fall and her mouth open partway.

Exasperated

She's so fed up, she refuses to even look at what's annoying her! Show the tension in her eyebrows.

Offended

Remember to use her whole body! Here she raises her chin and turns away to gather her strength.

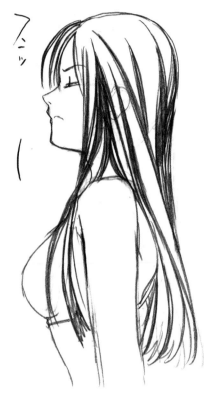

Thinking

Giving her raised eyebrows with this expression can suggest shock or even skepticism.

Laughing

Make her expression stronger by pushing up the arc of her eyes.

Hurt

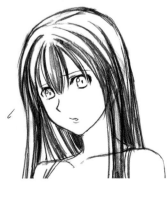

A small, yet open mouth can suggest she wants to say something but is uncertain.

Happy

Show her joy across her entire face.

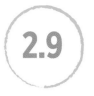

2.9 *Middle-Aged Woman*
(40-50 years old)

Just like our middle-aged man, her body has begun to soften and feel the pull of gravity now that she's reached her late 40s. Unless she works out, most of her muscles will change to fleshy fat, especially on her belly, bottom and upper arms. She should stand about 5 to 5.5 heads high. As for her face, the skin starts loosening and forming wrinkles. Pay attention to how lines form around her eyes and between her nose and mouth!

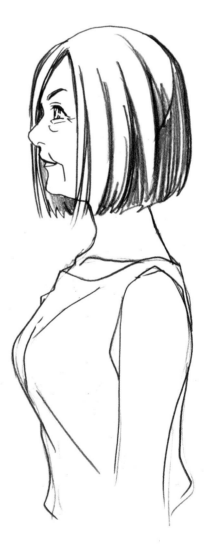

Normal

Her personality will show through the lines around her eyes—looks like she laughs a lot!

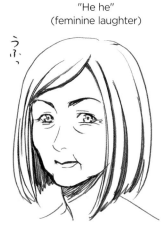

"He he"
(feminine laughter)

Depressed

Show her negative emotions subtly through the angles of her eyebrows and where she focuses her eyes.

Smiling

When she closes her eyes and smiles, don't forget to show the wrinkles around her mouth and nose.

"Mhmm"

Exasperated

Open her mouth asymmetrically to show her frustration. Notice how her eyes change as compared to when she smiles.

"Geez!"

Laughing

Give her a real sense of elegance with strongly defined lips and surrounding wrinkles.

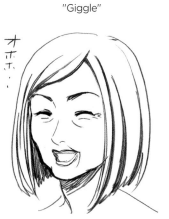

"Giggle"

Angry

Match her angled eyebrows with an open mouth and flashing eyes. Wrinkles can emphasize the movement of her jaw.

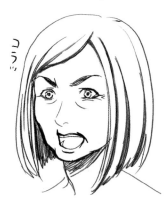

"Hey!"

Apathetic

Think low energy. She's closed off and focused inward with smaller mouth and eyes.

Crying

Show the strength of her emotions in her tensed eyebrows, and in how tightly her eyes are closed.

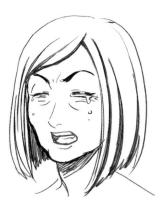

Elderly Woman (70-80 years old)

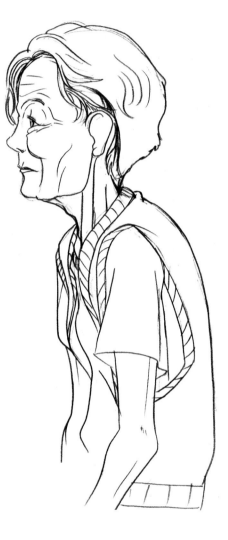

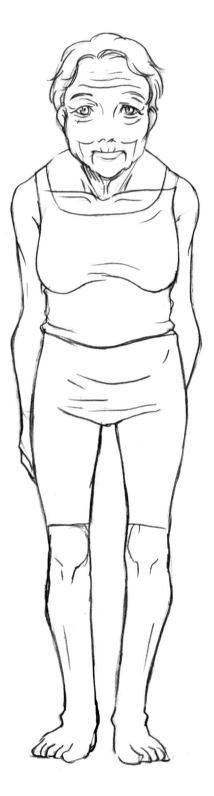

This character has reached her late 70s now, and stands about 5 to 5.5 heads tall. As she ages, her body loses flesh and muscle mass, and her skin begins to droop. Her legs and arms typically become thinner, her spine curves and her legs bow outwards to support her body. Make sure to show the shape of her bones clearly around her joints and her face, especially around her eyes.

Normal

When her face is at rest, her cheekbones are very prominent. Draw her skin hanging down and around her mouth and chin.

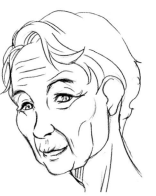

Scolding

She's giving you a piece of her mind! Her mouth's open wide with the corners turned down.

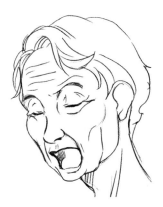

Surprised

Open her mouth for a smile and let her face follow.

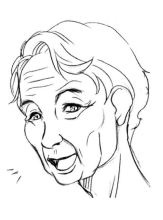

Disappointed

Show silent displeasure with a closed mouth turned down at the corners.

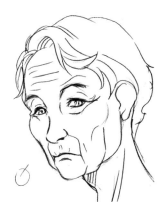

Upset

Draw her eyebrows tilted downwards at her temples and sweat running down her cheek.

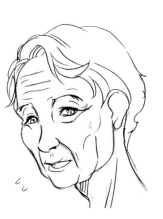

Laughing

Close her eyes and emphasize the wrinkles at the corners.

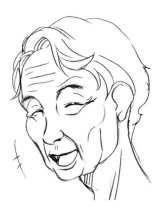

Sorrowful

A quiet expression with her eyes lowered and her mouth at rest.

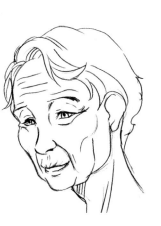

Crying

Close her eyes and show how her skin gathers around her mouth.

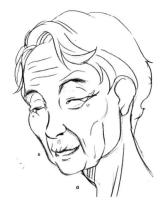

2.11 Baby

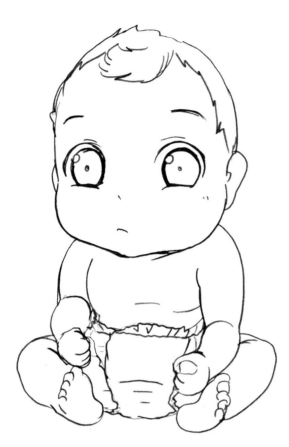

What a cutie! Our baby is just 2 to 3 heads tall, and his face is practically a circle. Even a child a few months old will have a rich variety of facial expressions, so observe him closely. This one can't even walk yet, but he'll thrash around plenty. HIs cuteness comes from the size of his head and wide forehead compared to his round little body, poochy belly, and chubby arms and legs. You may be surprised by how long a baby's legs can be when they're stretched out.

Normal

You can show the roundness of the face by pushing up the lower lid of the eyes.

Smiling

This closed-eye smile won't change the eyebrows much. Show off those first few teeth.

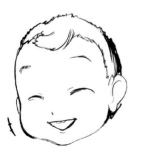

Sleeping

The key here is keeping the eyes and mouth loose rather than tight.

"Zzz, zzz"

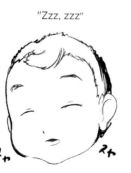

Crying

Poor baby! Time to get tight—scrunch up those eyes and brows and let the baby scream.

"Waaah!"

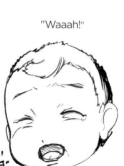

Aware

Narrow the eyes a little as the baby focuses on something.

Chapter 3

Character Types

Next we're going to match characters' expressions to their personalities. We'll learn to draw a variety of typical main character types and more!

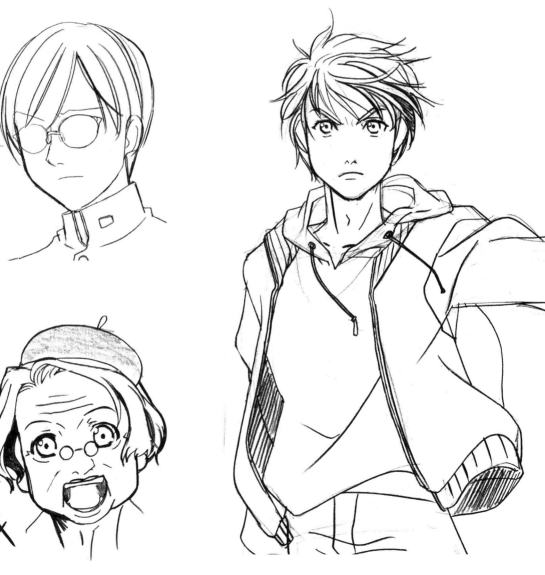

(3.1) Go-Getter

These student characters are the epitome of hard-working earnestness! Keep these two looking fresh-faced and ready to take on the world with bold expressions and carefully done hair. The go-getter tends to a scholarly, A-student look and often wears glasses. These are good characters to start off exploring expressions with, since their emotions show so clearly on their face.

"Hey, you!"

This girl could be the president or secretary of her student council, and you can bet she takes her responsibilities very seriously.

"Honestly..."

Don't forget to let her personality shine through her expressions.

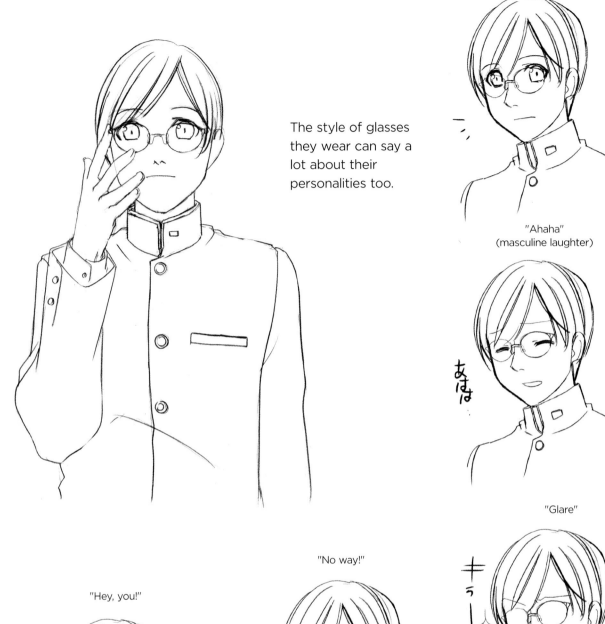

The style of glasses they wear can say a lot about their personalities too.

"Ahaha"
(masculine laughter)

あはは

"Glare"

キラーン

Sometimes a stern and mysterious look can make him look quite dashing.

"No way!"

え—

"Hey, you!"

コラッ！

A variety of distinctive expressions for your go-getter: You can add depth to your characters by showing a little softness in their expressions.

Hot-Blooded Hero

This passionate type dominates the main character role in manga.
They're marked by a strong sense of justice and an open heart.

"I did it!"

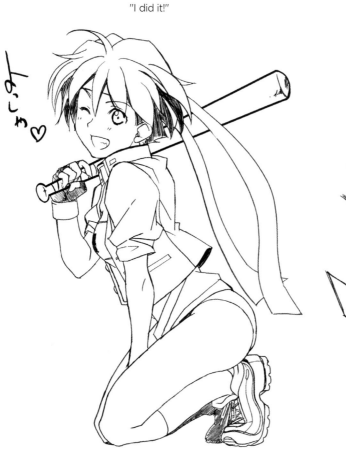

She's got a face full of confidence and maybe a little stubbornness too. Feel free to push her expressions over the top! She's quite the rough-and-tumble type—she's on any sports team that'll take her.

"I blew it!"

"Crackling flames"
(mental exertion)

You can count on her sticking it out and giving her all!

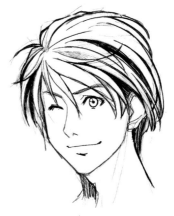

You can see the fires of justice in his eyes and in those strong eyebrows! He's always positive even in the darkest times, so try to avoid expressions of hopelessness. You can emphasize the difference between the hot-blooded hero and the anti-hero by giving this fellow a boyish haircut and a generally wholesome look.

"Ahhh!!"

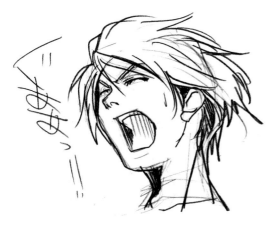

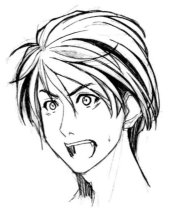

Make sure you reflect a strong sense of determination on his face, even in a difficult situation.

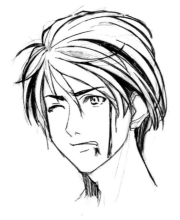

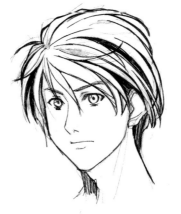

Anti-Hero

The anti-hero has become quite popular in a range of forms, from side characters to villains, and even leading roles! Cynical, moody and often cruel, they're the characters you love to hate.

Here's a powerful swordswoman.

"Evil grin"

Think dark. These characters almost always look haunted by heavy thoughts, unlike the hot-blooded hero. They have their own certain charm, especially with expressions that reveal the strength of their determination.

"Muahahaha"

Every anti-hero needs a good devilish look. Be bold and try deforming the mouth!

Villain

No doubt about it—these guys are evil! Aim for a cunning and cold-hearted look.

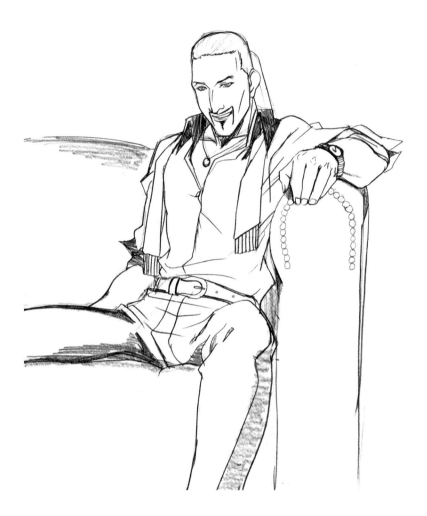

This particular fellow is a gang leader with scores of underlings. Remember to reflect the villain's power and arrogance in the face and whole body. Villains also tend to more sculpted, angular features with suspicious eyes. Try adding scars for an extra villainous design!

"Ha"
(sarcastic laughter)

Don't forget to draw your villains in moments of pleasure too.

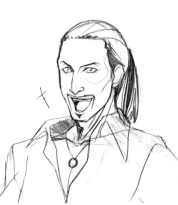

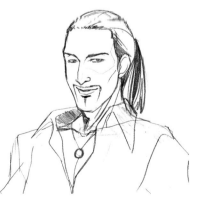

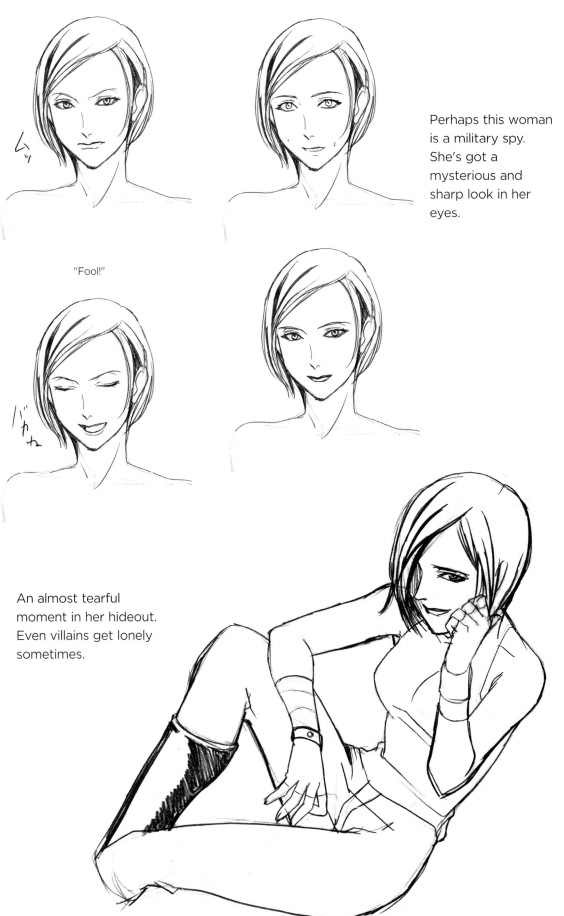

"Hmph!"

Perhaps this woman is a military spy. She's got a mysterious and sharp look in her eyes.

"Fool!"

An almost tearful moment in her hideout. Even villains get lonely sometimes.

Kind-Hearted Characters

Some of the sweetest people you will ever meet! These kind-hearted characters give off an aura of joy that makes everyone around them happy. Of course, that means their facial expressions are super important. Picturing a setting can help you visualize these characters, so let's try a café.

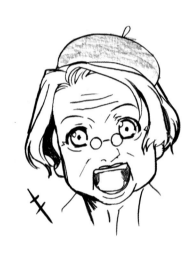

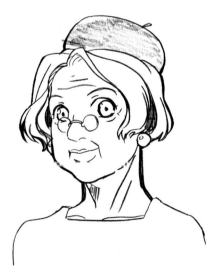

A friendly manager. He's got a kind smile with those bushy raised eyebrows, but he's maybe a little overcaffeinated.

A rich madam who comes to the café often. She's often meddlesome but very kind.

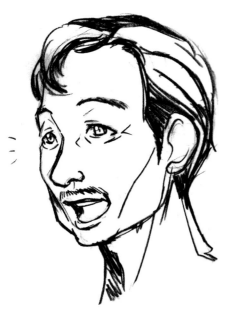

Our manager again in close up.

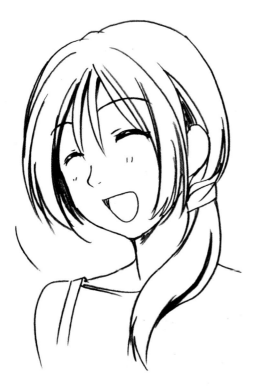

The waitress with a warm smile.

Here's a café waitress. She's got a peaceful look to her face and is always polite.

The Little Cutie

"Really!"

You guessed it, these young characters are all about cuteness. Their basic expression is a sweet smile with super huge eyes!

These characters typically stand just 4.5 to 5 heads tall. Always think childlike as you draw their proportions—keep their big wide eyes close to their teeny noses. As for their bodies, try thin limbs and a short torso with little gender variance. And when it comes to accessories like ribbons, bigger is better!

"Sniff sniff"

She's not amused.

Don't forget the little outfit details like buttons and bows when you draw her full body.

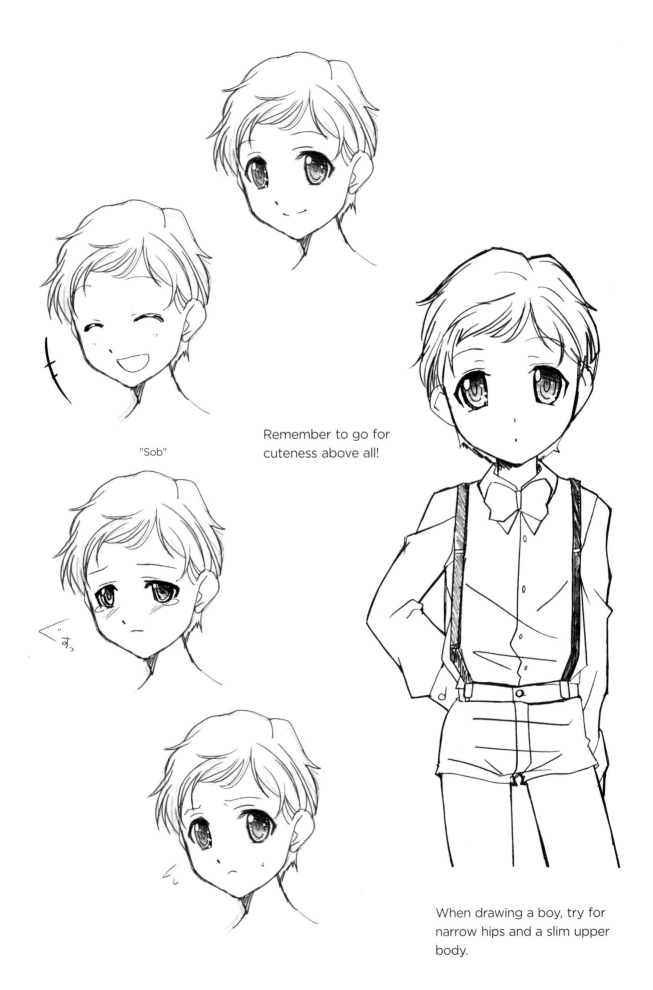

"Sob"

Remember to go for
cuteness above all!

When drawing a boy, try for
narrow hips and a slim upper
body.

3.7 *Trouble Makers*

These characters are constantly stirring up trouble throughout the course of a story. They are known for being two-faced and manipulative, so try to incorporate these traits into their facial features through the use of long noses and pointy chins.

When tackling a complex expression, try thinking about what that character might be thinking. This woman is scheming to get her own way.

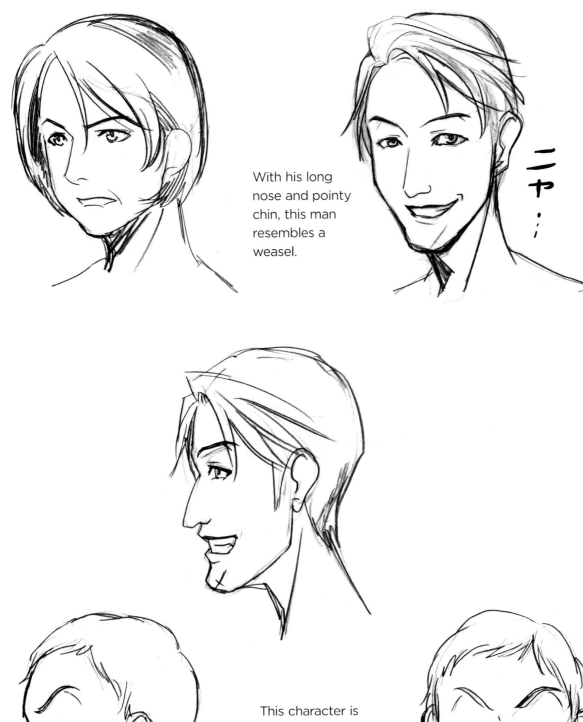

"Smirk"

With his long nose and pointy chin, this man resembles a weasel.

ニャ…

This character is reminiscent of the classic schoolyard bully.

The Big Boss

This man's clearly an evil mastermind. He's elegant and rich with a sinister smile. With the proper timing, one of those smiles can send shivers of fear down your readers' spines! He'll pretend he's being kind as he commits the darkest crimes.

"Muahaha"

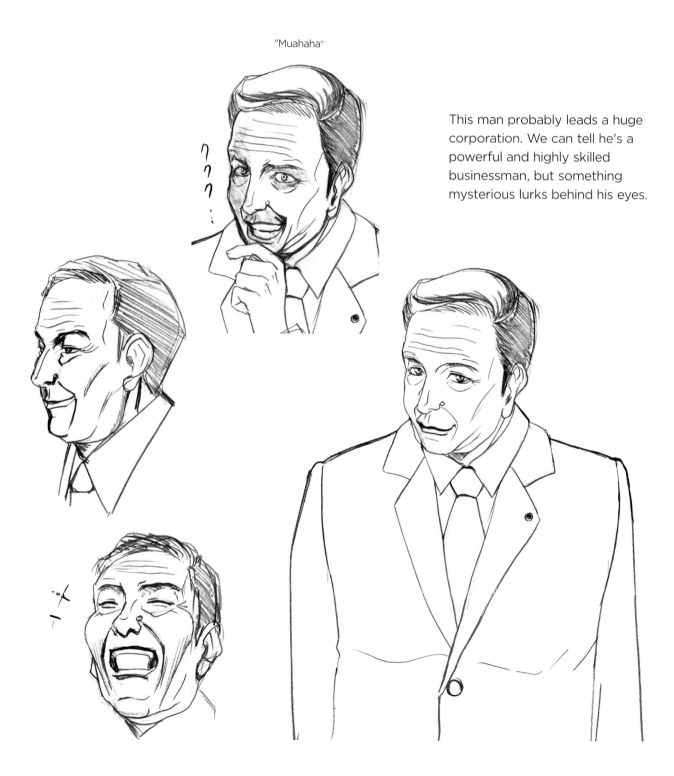

This man probably leads a huge corporation. We can tell he's a powerful and highly skilled businessman, but something mysterious lurks behind his eyes.

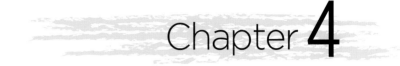

Chapter 4

Positive Facial Expressions

In Japanese manga, emotions fall into four basic categories: Joy, humor, sorrow and anger. In this chapter, we'll explore joy and humor, the two positive categories. A wide range of expressions can be found in these happier states of mind, and we'll use a variety of character types to model them.

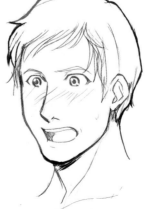

We'll be running through various expressions with four characters. As long as you take the time to first sketch some facial outlines and structures, you'll find yourself drawing balanced expressions.

Woman

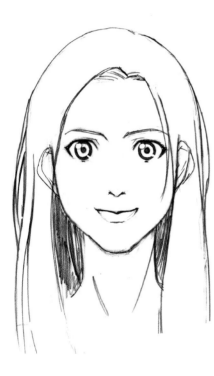

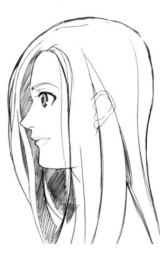

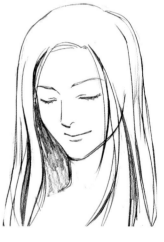

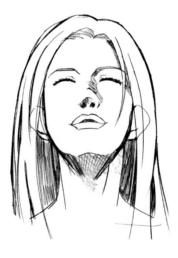

Girl

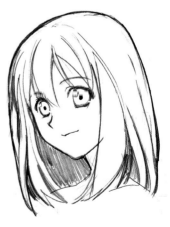

Let's start with each face at rest—think calm rather than just blank. This is an easy way to walk through the frontal, profile, low angle and high angle faces we've already introduced. When you first start drawing your characters, you might feel frustrated if your drawing doesn't look perfect. Don't give up! After a little practice, your characters will start to flow comfortably from your pen.

Boy

Let's practice until you can draw a face both from the front and in profile at the same speed. It might be easier to draw on lined or graph paper.

Man

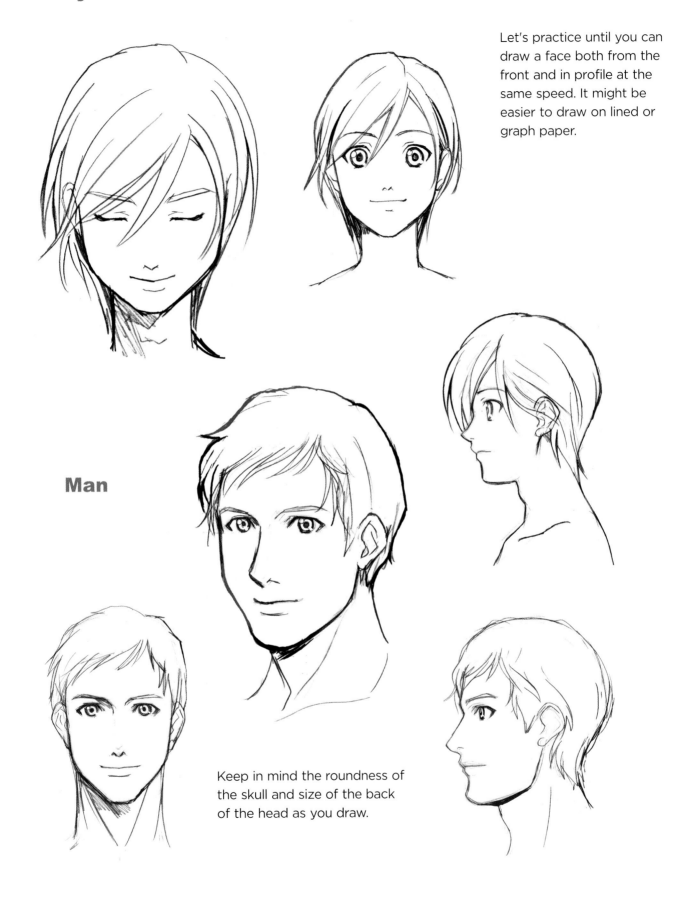

Keep in mind the roundness of the skull and size of the back of the head as you draw.

Joyful

Let's draw some happy, laughing faces! Pay attention to how the corners of the mouth and the eyebrows lift up to form expressions of delight.

Girl

An innocent and beaming smile often suits a younger girl and can be quite striking.

Woman

An adult woman character might laugh in a more sophisticated way, opening her mouth a little less.

Boy

Don't forget that there are many ways to laugh! Try drawing your character arching his back with a loud guffaw or chuckling silently to himself.

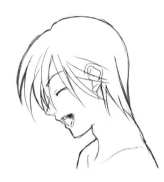

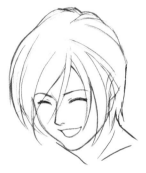

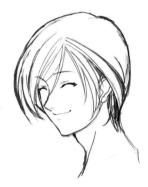

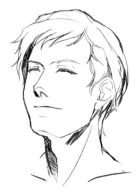

Man

Give your character a carefree look with a wide-mouthed laugh.

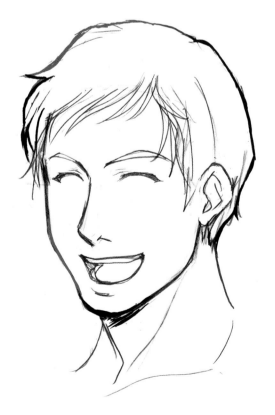

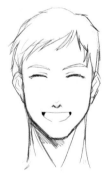

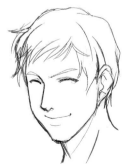

Content

These expressions capture that feeling of contentment when your mind is clear and refreshed and the future looks bright. Think happy and peaceful as you draw. The clouds have parted and the sky is blue again! Have your character look upward for a quiet moment of serenity.

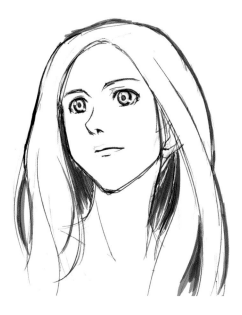

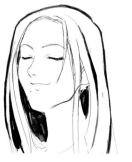

Woman

In all these expressions, both the man and woman are picturing something in their mind's eye.

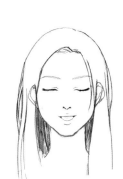

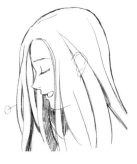

Man

Boy

Imagine your characters wrestling with an unsolved problem. Then draw their expression of relief and peace as they find an answer—like finally pulling out a cork stuck in a wine bottle!

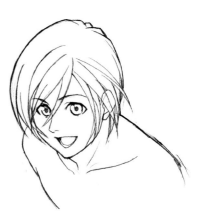

Girl

Maybe your characters' serene expressions are directed toward the person they're talking to.

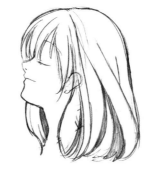

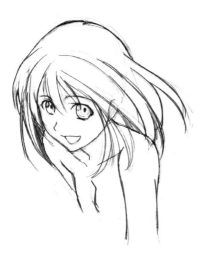

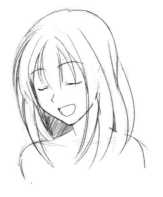

4.4 Reminiscent

These various expressions all come from looking back on happy memories and laughing reminiscently.

Woman

Someone or something she's remembering has brought a peaceful smile to her face.

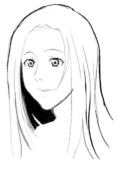

"He he" (giggle)

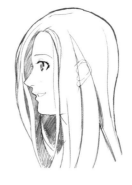

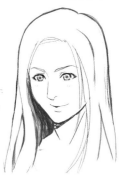

Man

Nostalgia of a happy memory can also give your character a wistful expression.

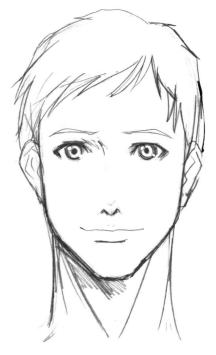

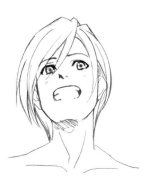

Boy

This kid bursts out laughing as he remembers all the trouble he got into today.

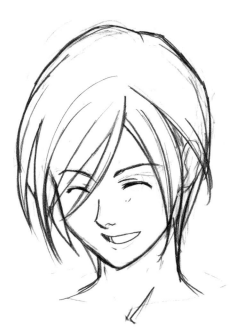

"He he" (giggle)

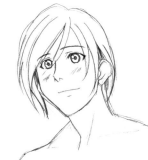

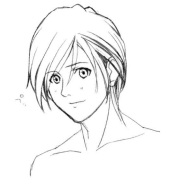

"He he" (giggle)

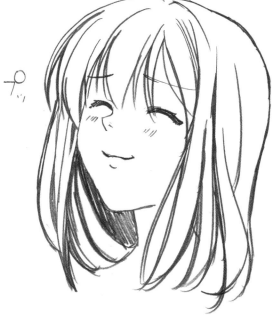

Girl

She's surprised herself just now with sudden recollection. "Oh, I remember!"

4.5 *Pensive*

These expressions show that these characters are visualizing something in their heads. Show their faces shifting or smirking depending on the nature of what's being imagined.

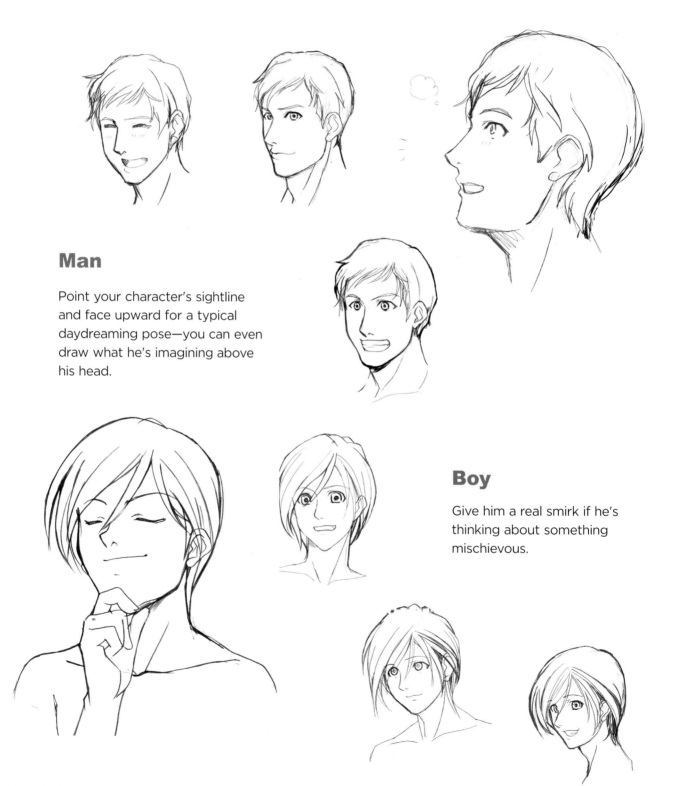

Man

Point your character's sightline and face upward for a typical daydreaming pose—you can even draw what he's imagining above his head.

Boy

Give him a real smirk if he's thinking about something mischievous.

Girl

What's she daydreaming about? Keep what she's visualizing in mind as you draw to capture her exact expression.

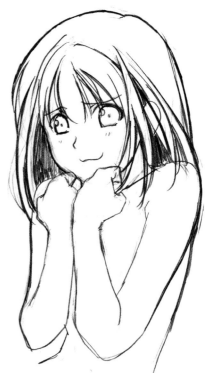

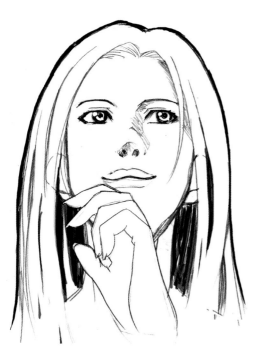

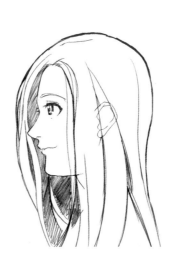

Woman

Giving your character a more serious expression can suggest she's scheming something.

Excited

These characters are happily anticipating something that's to come.

Girl

She's just too excited to wait! This hand-to-chin pose conveys a different feeling than the ones shown on the previous page.

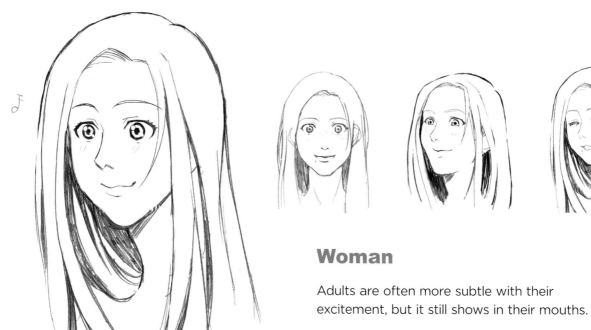

Woman

Adults are often more subtle with their excitement, but it still shows in their mouths.

Boy

Energetic poses can work well for excitement, depending on your characters' personalities.

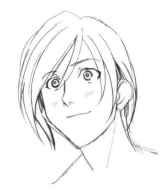

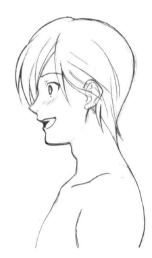

Man

Sparkles go nicely with shining bright eyes.

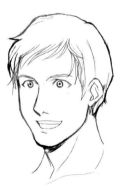

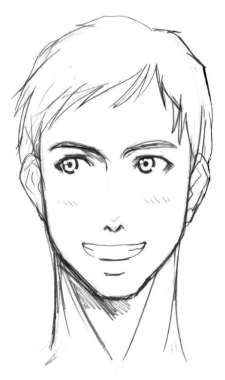

Relieved

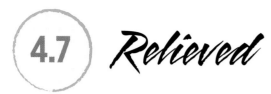

What a relief! Sighs are useful when drawing characters letting go of their worries.

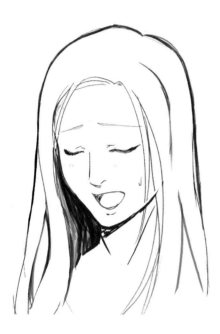

Woman

Here are a few different ways to show the moment when characters let themselves relax with a sigh.

Girl

Doesn't it feel good to draw someone feeling relieved?

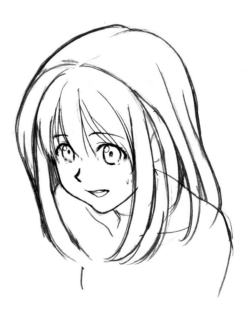

"Phew!"

Boy

There are many different types of sighs, and facial expressions differ for each one. Which sigh looks like he just escaped something scary?

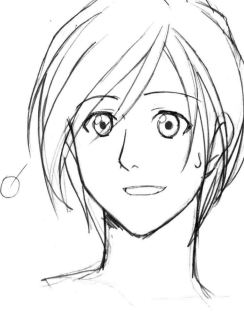

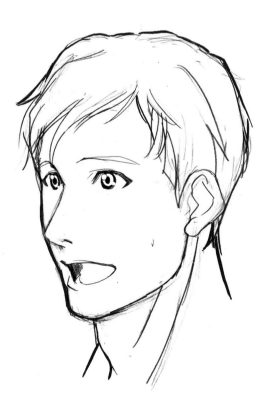

Man

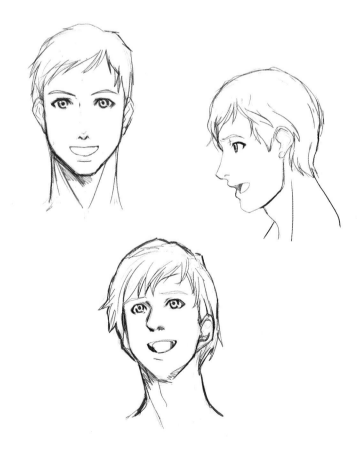

A genuine smile extends all the way to the eyes. Sometimes a character is smiling at someone else or just because they are happy.

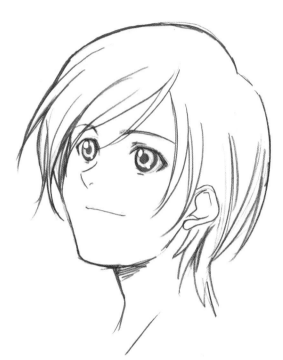

Boy

Here's a more pensive look, a bit like a reminiscent smile.

Man

Smiling characters are often shown with their eyes squeezed shut as a result of their big grin!

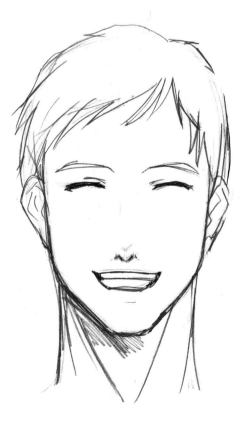

Woman

Pull up the edges of the mouth, scrunch her eyes closed and arch her eyebrows. Isn't it weird how just a few small changes can show an entirely different emotion?

Girl

You can give her a variety of looks by changing the angle of her face.

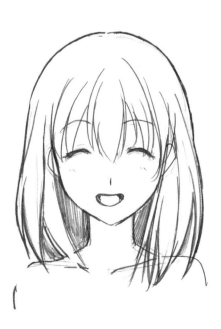

Laughing

Open those mouths up wide and let their laugher burst up from the bottom of their stomachs! There are countless ways for a character to laugh.

"My stomach hurts from laughing!"

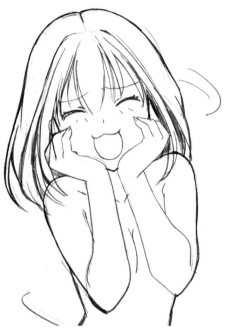

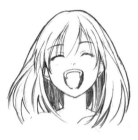

Girl

Try walking your characters through several stages of laughter. Why not let them wriggle with delight?

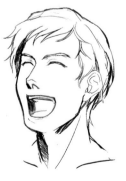

Man

The basic muscle movement won't change with age, but the way the skin folds will.

Boy

Try a big belly laugh! Draw your character holding his stomach and bending forward to show the force of his laughter.

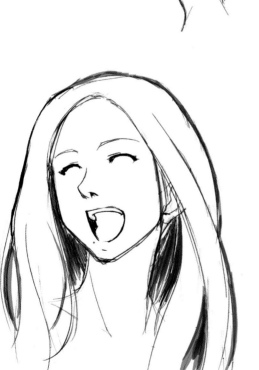

Woman

Pay attention to how the shape and angle of her closed eyes shift depending on the direction she faces.

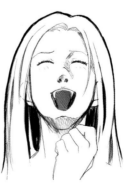 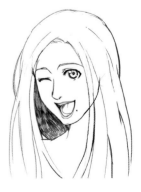

(4.10) *Amazed*

"It's just like a dream!" These characters can't believe what they're seeing. This expression can be quite close to a joyful one.

Boy

Try matching these reactions to different varieties of wonder, like astonishment, rapture or shock.

"Ba-dump, Ba-dump"
(thumping heart)

Man

Even adult characters can look starry-eyed. Express his sense of amazement with dilated pupils and a mouth hanging open in surprise.

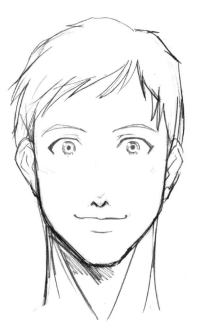

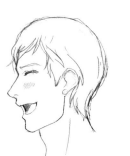

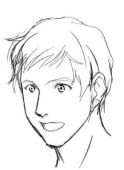

Girl

Imagine her discovering an amazing treasure!

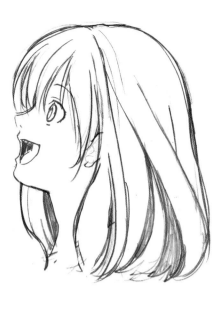

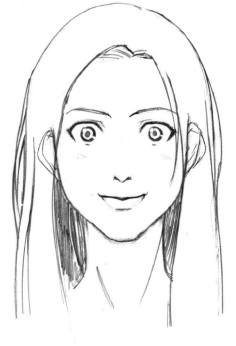

Woman

Sometimes characters respond to more than just what's in front of them. This woman is daydreaming, so pay close attention to her eyebrows and the shape of her eyes.

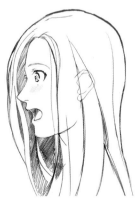

This expression is usually reserved for when a character gazes at loved ones, especially kids, with gentle eyes.

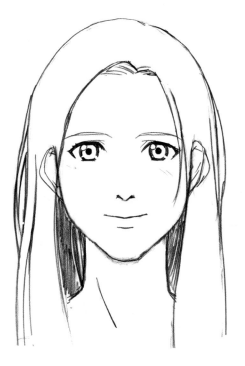

Woman

A warm smile can make this look quite maternal.

Man

As you draw these expressions, imagine the real sense of peace felt by gazing at something or someone you treasure.

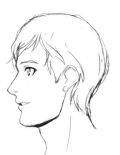

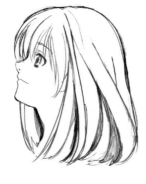

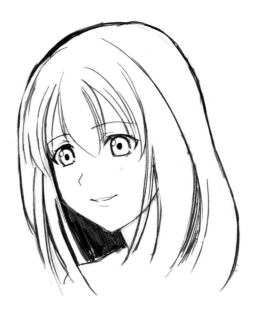

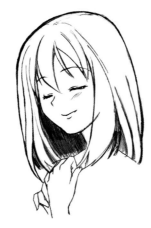

Girl

Try to capture a gentleness in the eyes as you draw these heartwarming expressions.

"Sigh"

Boy

Sometimes teenagers (especially boys) act quite childlike when looking at the ones they hold dear.

4.12 *Mischievous & Goofy*

Goofy plans and practical jokes are common in manga stories. Here are a few ways to show your characters having fun.

"Shhhh!"

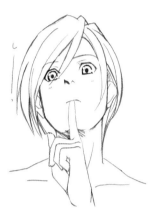

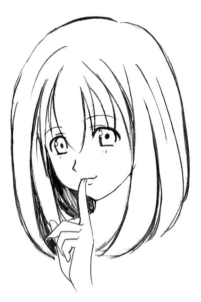

"Shhhh!"

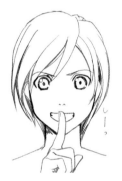

Before you can play a practical joke, you have to keep the secret under wraps. Bring the index finger up to the lips for the universal quiet gesture.

"Shhhh!"

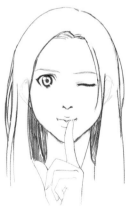

"Shhhh!"

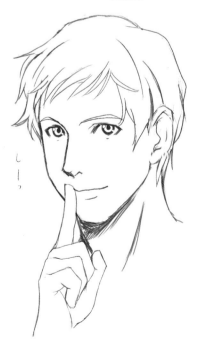

Switch up your pose by changing the eyes and mouth. Imagine the person the character is trying to shush.

"Dazed"

ほえ

Looking funny and being funny often overlap!

"Funny noise"

しーっ

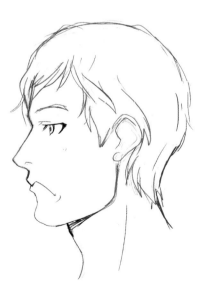

It's important to be able to not only draw your characters looking clever, but also looking silly and cartoony in ways that reflect their personalities.

Forgiving & Understanding

Forgiveness towards a person who hurt you doesn't always come easily. Call on some of your own memories of compassion while you draw these expressions.

These characters aren't being forced to forgive, but are choosing to accept an apology, saying "If you insist ..."

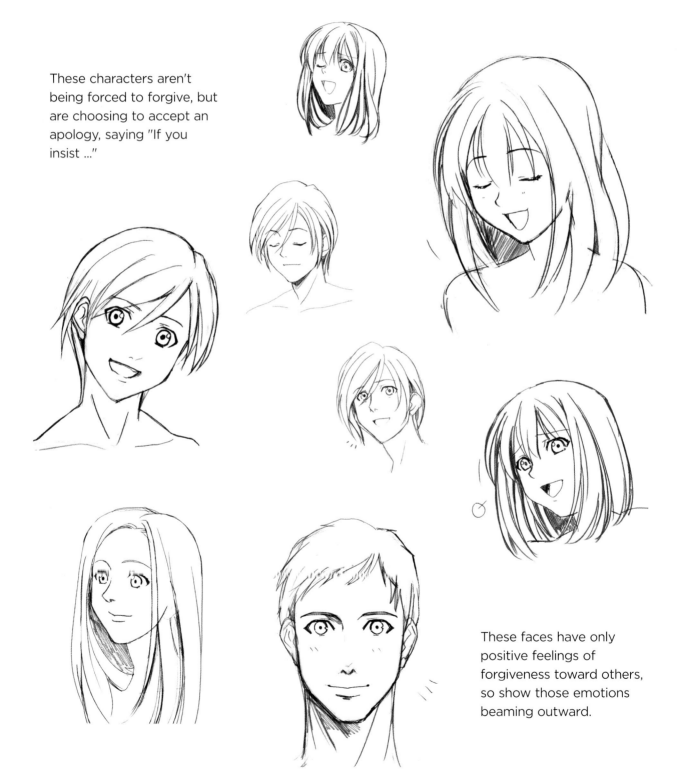

These faces have only positive feelings of forgiveness toward others, so show those emotions beaming outward.

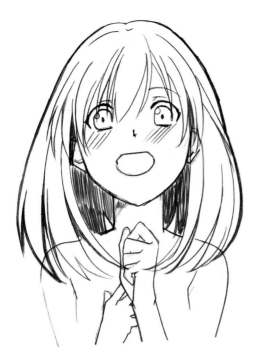

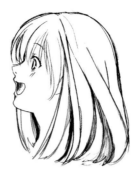

These big-hearted characters feel others' happiness as if it were their own. They'll even accept opinions they can't agree with. These kinds of accepting expressions can really come in handy.

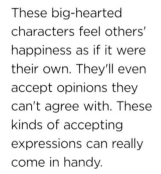

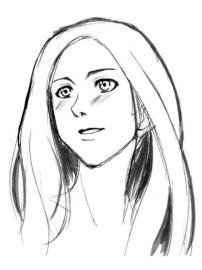

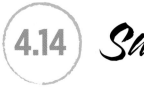

4.14 Savoring

These are the kinds of faces you make when you're enjoying or about to enjoy a good meal.

They're quite impressed by what they're about to eat! As you draw, keep in mind how different flavors such as sweetness and spiciness can affect facial expressions. More mature characters may react to a mouth-watering meal by simply licking their lips or salivating a smidge.

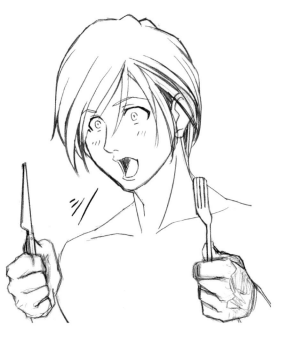

"Aww"

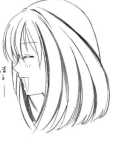

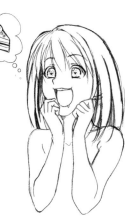

Even adults drool sometimes!

"Chomp chomp"

When your characters are tasting something truly delicious, it's good to match their expression of satisfaction and full mouth with a comment about the food. Try something like, "Scrumptious!"

"Tastes great!"

"Delicious"

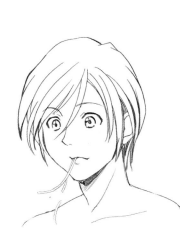

"Delicious"

Silly expressions can also convey how truly tasty the food is.

Confident & Inspired

These expressions are bursting with determination. As you draw, think power and stability for whatever life throws at your characters.

People tend to make a lot of hand gestures when they get fired up.

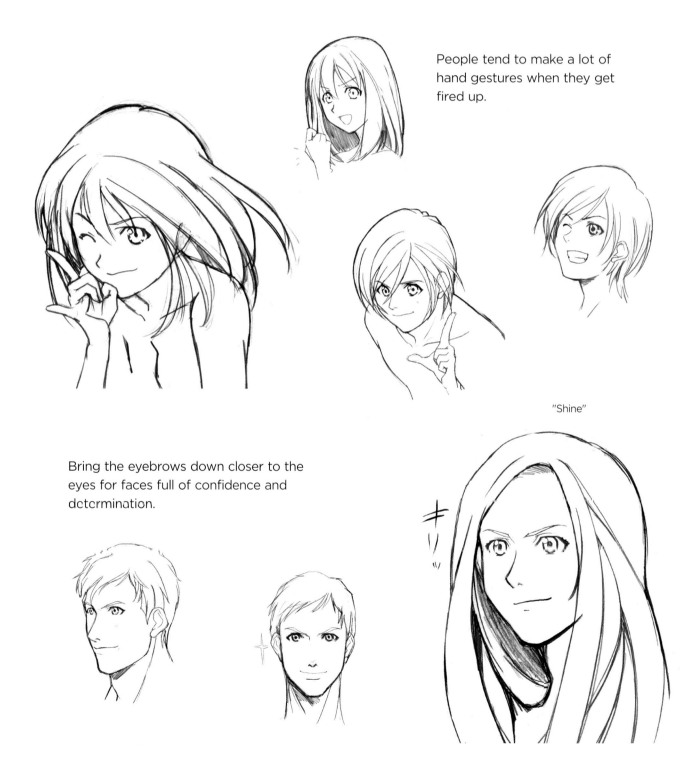

"Shine"

Bring the eyebrows down closer to the eyes for faces full of confidence and determination.

These eyes are positively shining with passion! Show the way they glitter with bright highlights and maybe a sparkle or two.

Gleaming eyes can also convey cunning. Try adding a bit of shine to a sharp or funny expression.

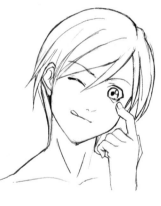

"Smirk"

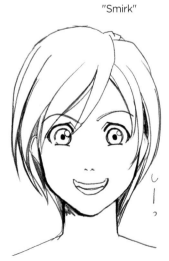

Sleepy

These are the kinds of faces people make when they're sleepy or even drifting off to sleep. Eyes close and mouths loosen as they sink into slumber.

Sleepy people often start focusing on a single point without realizing they're doing it! Give their eyes a dazed look and let their face slacken.

"Zzz, zzz"

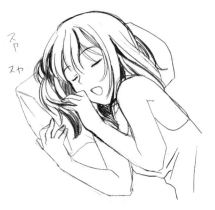

"Zzz, zzz"

"Nodding off"

Sometimes people can't even hold their head up anymore as they drift off.

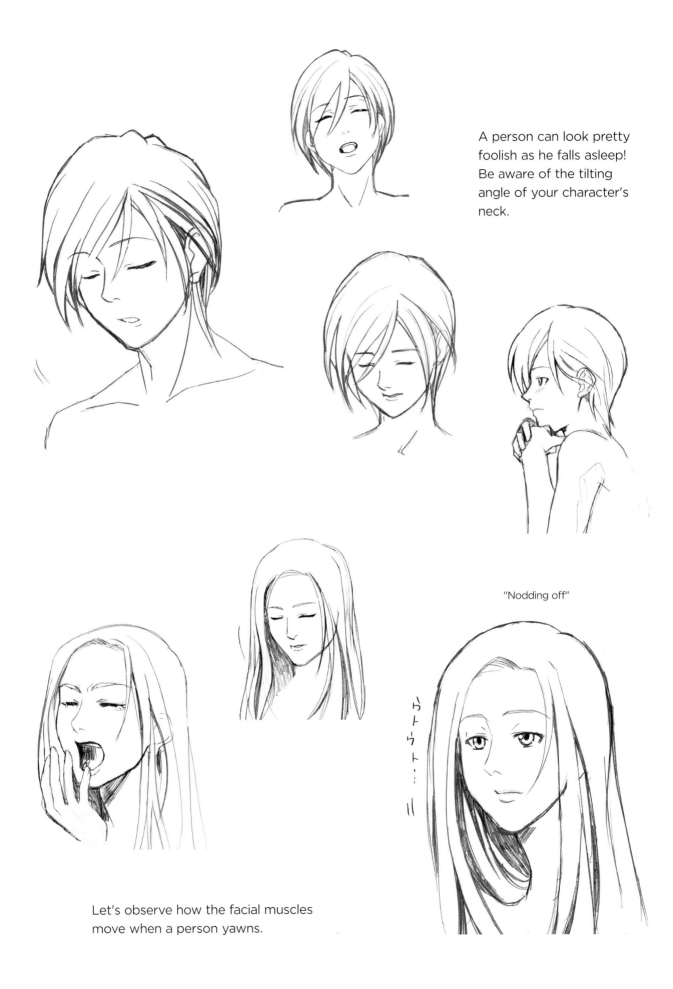

A person can look pretty foolish as he falls asleep! Be aware of the tilting angle of your character's neck.

"Nodding off"

Let's observe how the facial muscles move when a person yawns.

4.17 Falling in Love

These are expressions in which characters try to keep their growing emotions under control. But their feelings of love and affection still show on their face!

There's a real rush of excitement when you fall in love or get emotionally involved. Try to capture the feel of a pounding heart as you draw these expressions.

"Ba-dump, Ba-dump"
(thumping heart)

"Blush"

"Ba-dump, Ba-dump"
(thumping heart)

Sometimes enamored expressions can get mixed up with embarrassment. Add a glazed look to their eyes.

Overcome with Emotion

Time to let the tears flow. As you draw, keep in mind that these are happy tears prompted by a positive event.

"Touched"

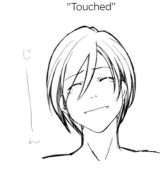

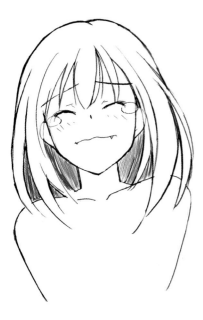

Our teens are weeping with sheer delight, maybe because they just passed their college exams. Closed mouths can tell us that they're holding in a big sob.

"Sob"

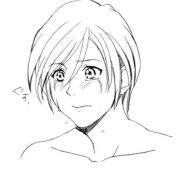

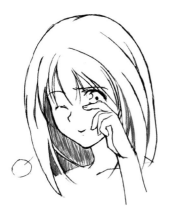

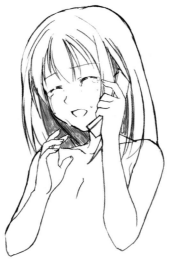

Adults also cry with delight, although they may do so more quietly. These characters are feeling a deep happiness—maybe something great happened to a loved one, or their partner just proposed to them! Be delicate as you draw the line their tears make running down their face.

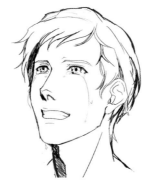

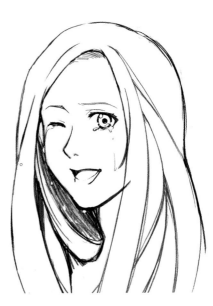

Focused

What kind of expression do you make when you focus in on just one thing? Remember to draw these faces with their eyes fixating on a single point to convey their concentration.

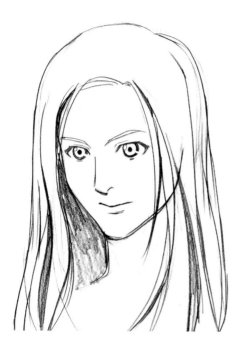

We focus hard in important situations like taking tests or working on something tricky. Isn't it refreshing to draw a dignified and undistracted face?

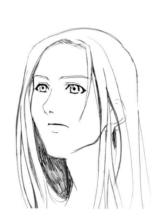

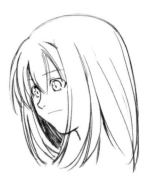

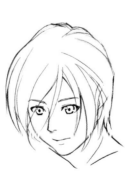

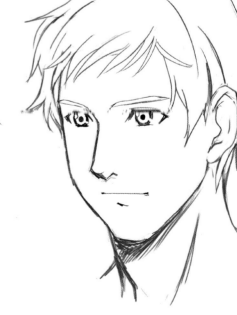

These eyes have a real power to them, unlike in blank expressions.

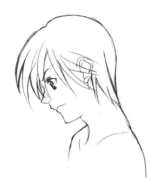

Negative Facial Expressions

In this chapter, we'll look at the remaining two basic emotions typically found in Japanese manga: Sorrow and anger. Just like the previous chapter, we'll use a variety of character types to explore these states of mind.

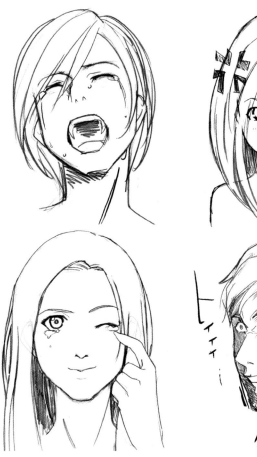
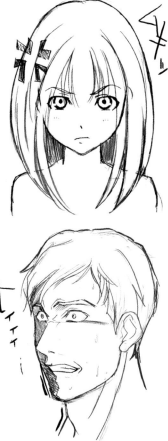

Speechless

This dumbstruck look starts with the eyes: Widen those whites and shrink those pupils!

"What?!"

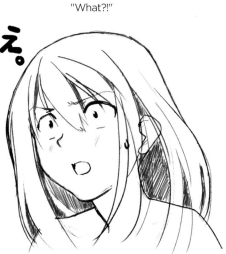

Girl

Emphasize her feeling of being off-balance by drawing her face with rough, or even jagged lines.

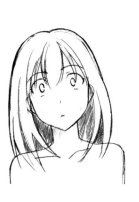

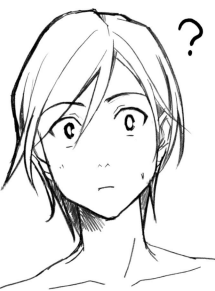

Boy

For an unpredictable character, why not mix some moments of cuteness into the shock?

"What?!"

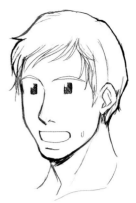

Man

For an adult character, you can suggest inner shock just by altering the angles of the eyes and eyebrows.

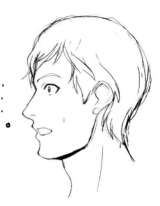

Woman

Draw her eyes as simple dots to really drive home her sheer befuddlement.

"What?!"

5.2 Angry

Since anger is a very common expression in manga, practice drawing this emotion on characters of all ages and genders.

"War cry"

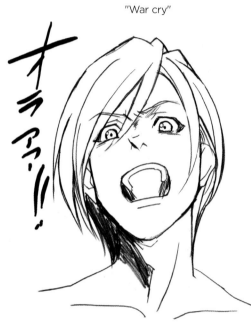

Boy

Younger characters often express their anger directly. The degree of control over their emotions will differ from character to character, depending on their personality.

"Geesh!"

Man

A man may get extremely angry, but he can show mental maturity by expressing that anger through clenched teeth and flashing eyes.

"Grinding teeth"

"Grinding teeth"

Girl

Our girl character expresses her anger directly too. Make sure we feel the force of her emotions in her expression and in her body language.

"Hey!"

"Grrrr"

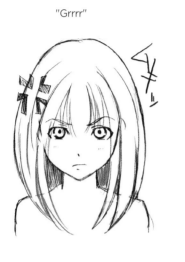

"Glare"

"Shriek"

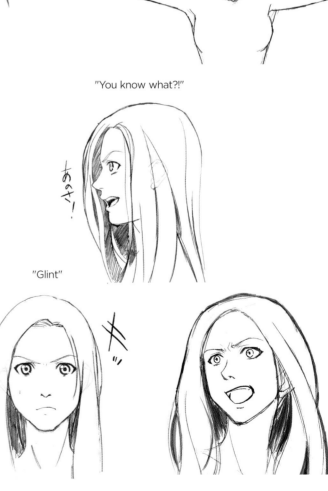

Woman

Try drawing a more inwardly directed anger for a mature woman. Don't forget that sometimes people make silly and endearing expressions when they're mad.

"You know what?!"

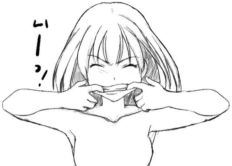

"Glint"

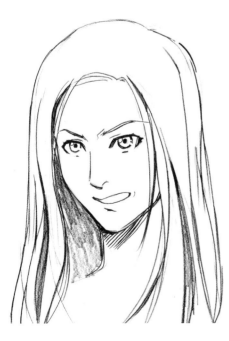

(5.3) *Outraged*

This is the moment when a character is unpleasantly surprised by an unexpected situation. It's funny how this face can almost look like excitement!

Girl

Sometimes a person will scream and tense up instinctively when surprised. Make sure you open the eyes wide.

"Shriek"

"Ahhhh!"

"Ba-dump, Ba-dump" (thumping heart)

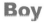

"Jolt of surprise"

Boy

After an initial reaction of outrage, a character may regain his composure and express relief.

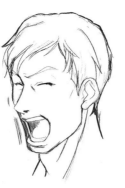

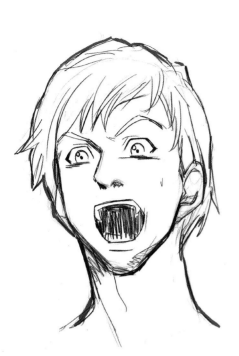

Man

Outrage can sometimes squeeze tears out of the eyes or make muscles go rigid. Don't forget to use the whole body for these expressions.

"Ba-dump, Ba-dump"
(thumping heart)

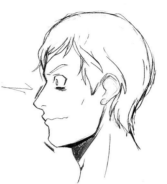

"Flinch"

Woman

Drawing from observation can help you understand how the face changes shape with outrage. Think about how the skin wrinkles when you scowl.

"Shiver"

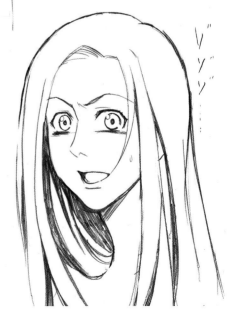

 5.4 *Embarrassed*

These are the kind of faces for when characters make honest mistakes or find themselves in the wrong place at the wrong time.

Woman

Shy characters' cheeks often flush red. They might try to cover their face or make a joke to distract from their self-consciousness.

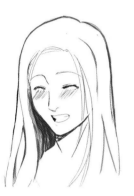
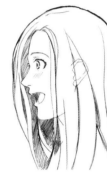

Girl

Adding hand motions is a great way to accentuate this emotional state.

Boy

Try exaggerating the expression to cartoony extremes!

"Goofy"

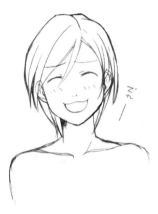

Man

Some adults (especially men) may feel ashamed by their bashfulness, so they might get flustered and try to downplay their emotions.

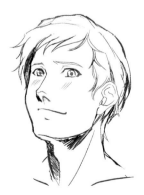

5.5 *Remorseful*

Let's draw apologetic faces next. You can significantly increase the emotional power of your story once you master more nuanced expressions like regret and remorse.

For an adult's apology, start subtly, with the eyes. Show her remorse and shame through lowered lashes and gently slanted eyebrows.

"Sorry"

Try developing the mood of a scene by drawing your character unable to apologize outright. Adding a cynical or angry twist to the mouth can bring realism and depth to the expression.

"Sorry"

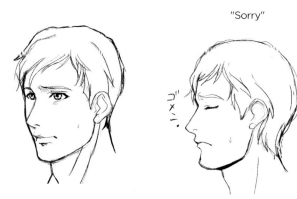

"I'm sorry"

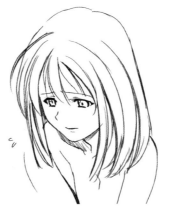

Younger characters might play up their cuteness with an apologetic pose. You can show innocence through her upward-angled eyebrows too.

"I'm sorry"

"I'm sorry"

Try mixing in a bit of arrogance if it fits your character's personality. Closing one or both of the eyes can be an easy way to show discomfort with apologizing.

5.6 *Anxious*

Ever notice how worried people often touch their faces with their hands? Use your character's whole body to convey both overdramatic freak-outs and more subtle, inner feelings of anxiety.

"What am I gonna do?"

There's a wide range of expressions between a simple fret and an extreme bout of anxiety. For a more reserved expression, imagine your character as oblivious to the world around him, and focus the eyes on a single point.

Keep in mind the importance of whatever's got your character worried. For small concerns, he might look up in the air and brood, but for more serious matters, he may drop his eyes and bite hard on his lip.

"Hmmm"

There are many ways to express anxiety in a younger character. If she's caused the problem, her face will show her guilt and worry quite clearly. Try out some different hands-to-face poses too.

"Hmmm"

An adult's anxious face usually looks kind of scrunched up. Have her bite her lower lip, lower her eyes and add a somber tone with the concerned furrowing of her eyebrows.

"Ummm"

"Ummm"

5.7 *Exhausted*

"Oof, I'm so tired!" Try to show a real sense of mental and physical exhaustion in these expressions.

A good sigh starts with the shape of the mouth itself. Imagine your character letting her mouth hang open a little, then exhaling slowly. Add a cloud symbol to make the sigh even clearer. Tilting the face downward can also give the impression of tiredness.

"That's enough!"

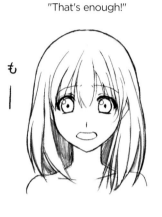

"I'm beat"

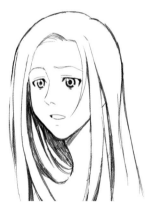

"Sigh"

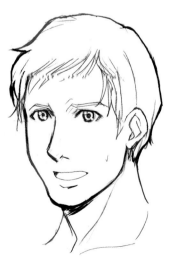

"Sigh"

"Ahh, I'm tired"

"I'm tired"

Now it's time for some seriously exhausted faces. Draw their drowsy lids hanging down and partly covering their pupils. Adding sunken cheeks and shadowy eyes can give your character an even more haggard, worn-down look.

"Dizzy"

"Sigh"

5.8 Stressed

It's easy enough to use a sweat symbol, but you'll achieve much more effective expressions if you are able to draw frustration or embarrassment in the face itself.

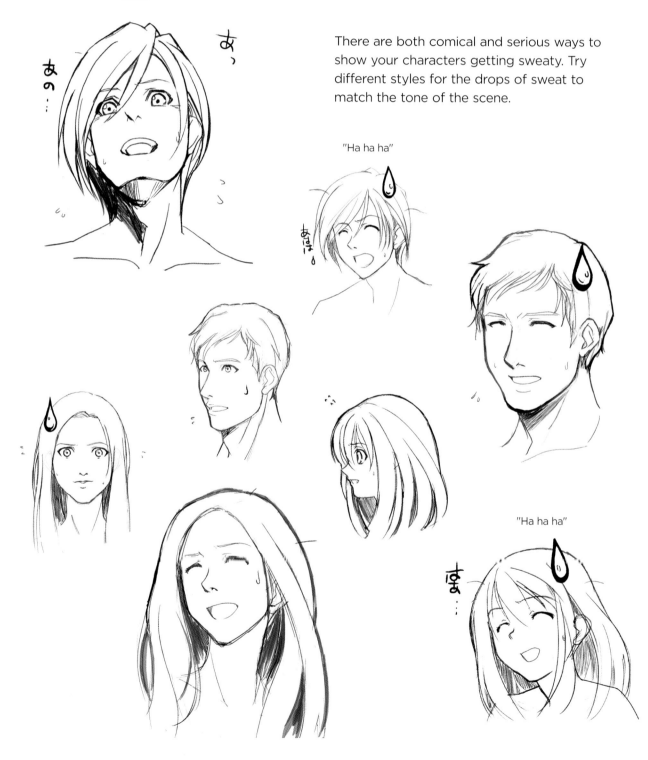

"Hello?"

There are both comical and serious ways to show your characters getting sweaty. Try different styles for the drops of sweat to match the tone of the scene.

"Ha ha ha"

"Ha ha ha"

Expressions of stress can also be quite varied. Experiment with comical looks, as well as cartoonishly exaggerated or serious ones.

"I see"

"Really!"

"You must be joking!"

"Ha ha ha"

5.9 Concerned

Concern is a more nuanced expression of stress, such as when you are worried about a loved one's well-being or you can't control the outcome of a difficult situation.

The characteristic features of this emotion are a tightly closed mouth and haunted eyes. Try bringing elements of anger into these expressions too.

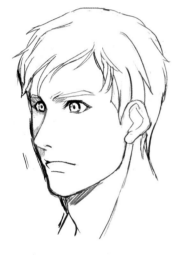

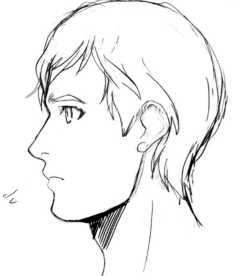

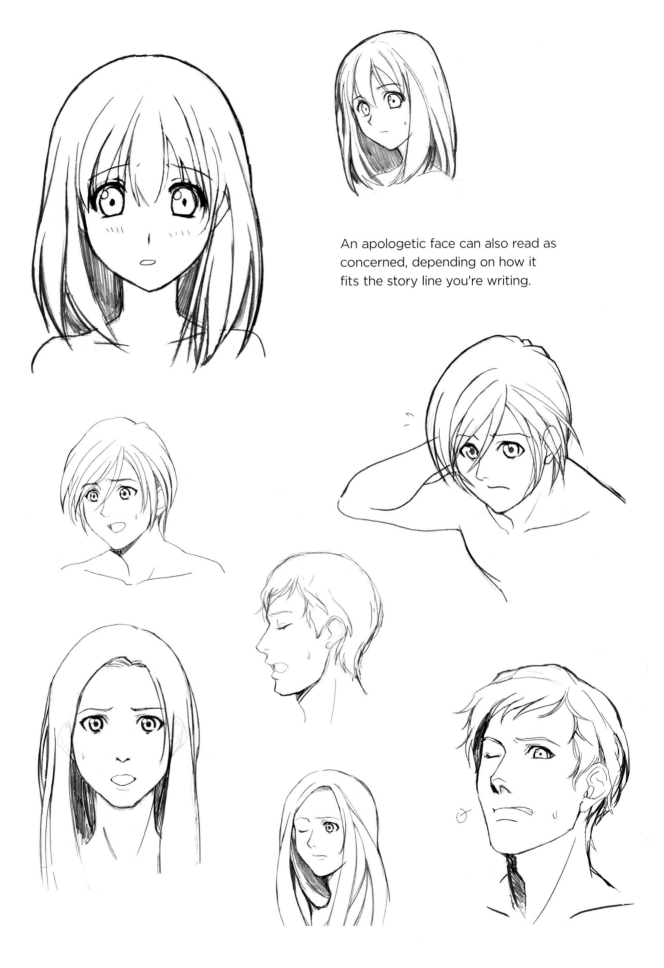

An apologetic face can also read as concerned, depending on how it fits the story line you're writing.

Heartbroken

The joy of falling in love goes hand in hand with the misery of loneliness.

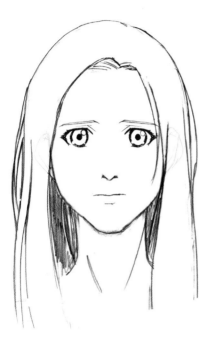

It can be easier to draw by calling on your own memories of being unable to see your loved ones or suddenly finding yourself all alone.

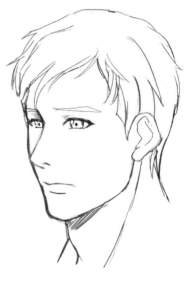

The eyebrows can often be the key difference between love and loneliness. Try slanting them upward or furrowing them.

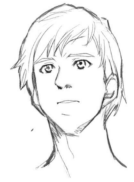

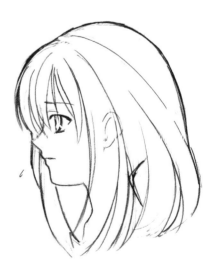

(5.11) Depressed

When characters feel hopeless or despondent, don't be afraid to experiment stylistically. Drawing with a thinner line can make your characters look washed out and pale with emotion.

Covering your face with your hands is a classic pose for indicating depression. Closed, half-closed or downcast eyes work well too.

"Sigh"

"Sigh"

"Sigh"

5.12 *Afraid*

To really capture a sense of fear, add some bold and scratchy shading. Dialogue and sound effects can help drive these expressions home too.

"Oh!"

A sudden fright can freeze you up and lock your facial muscles into an awkward expression. Open your characters' eyes up wide and show their pupils completely surrounded by white. Open their mouths wide, or pull back the lips to show clenched teeth. Try drawing with thick lines and heavy shadows to build a mood that reflects their frightened state of mind.

"Nooo!"

"Gasp!"

"Gasp!"

For real spine-tingling horror, the whole body reflexively launches into fight-or-flight mode. Show the blood draining from the face, the skin prickling with goose bumps and the motion of the shivers and shakes. Open the eyes up as wide as possible and use protective body language, especially with the hands.

"Gasp!"

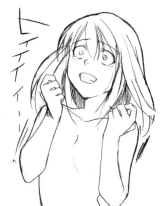

"Gasp!"

"Gasp!"

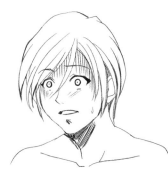

5.13 Shocked

Now let's capture the expressions people make when they've been stunned.

Imagine how they must be feeling and channel that into your drawing. Time may seem like it's grinding to a stop as the blood drains from their face. Add some jaw-dropping realism by letting their mouth hang open, and also by shrinking their pupils to a tiny point. Why not add some abstract lines of pure jagged shock?

え、

"What?"

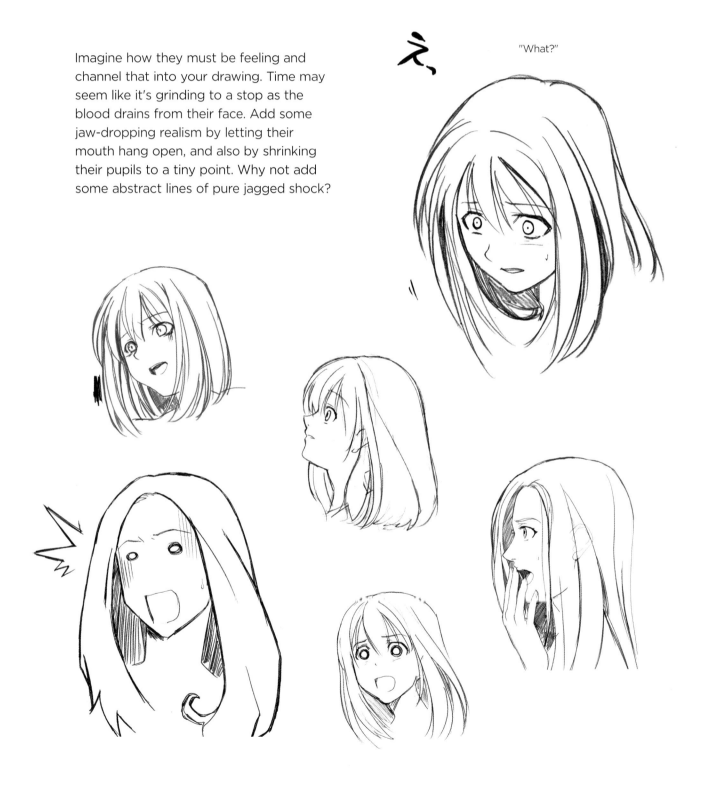

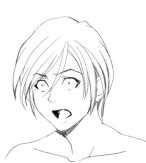

Some shocked expressions are more similar to confusion. Draw the characters as if they can't fully grasp the situation they're in. Pay close attention to the whites of their eyes and the wideness of their lids and mouth. Adding a few vertical slashes by the eyes can give them a paler, even more stricken look.

"Shock"

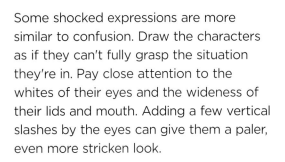

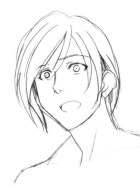

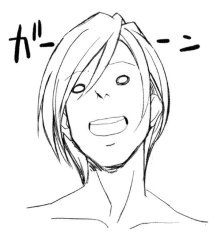

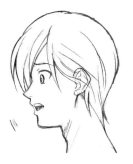

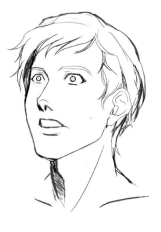

If you're going for humor, draw that mouth as big as you please. A silly shocked expression can really cut the tension of a horrifying scene.

Grossed Out

All of these characters have just witnessed something truly revolting.
Experiment with distorted mouth shapes that twist and grimace with disgust.

There are generally two kinds of reactions to seeing something disgusting: A character either recoils with shock or evaluates the object in a calm manner. A nasty surprise can cause a really overdramatic reaction, while a more low-key expression might hold a deep scorn and hatred in the eyes.

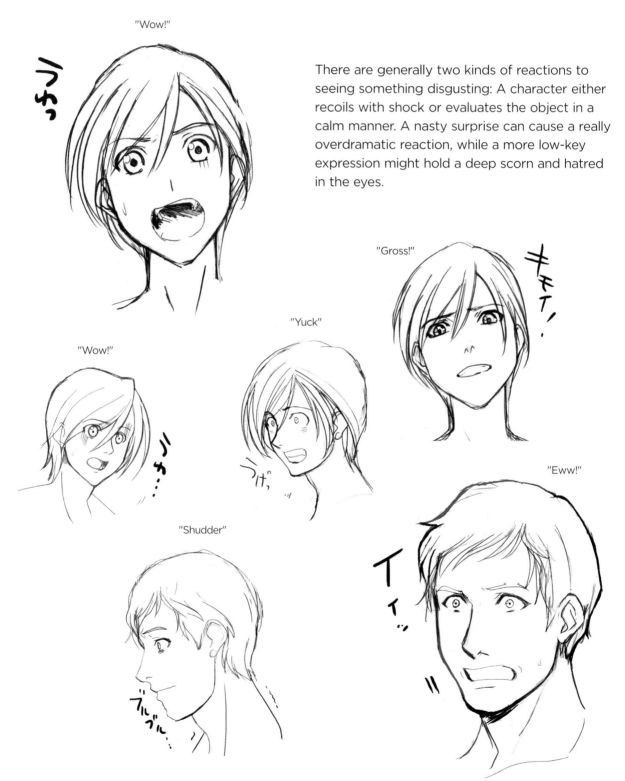

"Wow!"

"Gross!"

"Yuck"

"Wow!"

"Eww!"

"Shudder"

A really deep disgust can leave you feeling nauseated. It's a similar involuntary reaction as sheer horror—the whole body recoils and we can see her emotion in every muscle. Show her rejection from her clenched teeth to her hunched shoulders and gesturing hands. Her eyes are fixed on the object of her disgust, tracking its every move.

"Oh no"

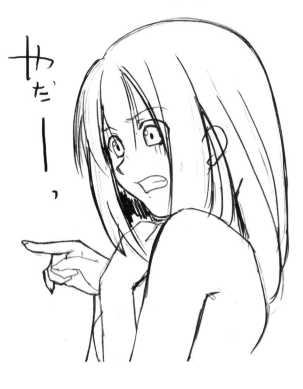

"Shudder"

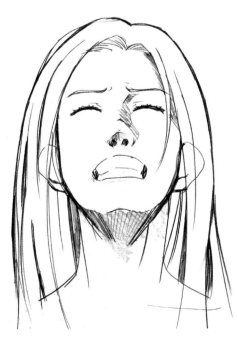

"Yuck"

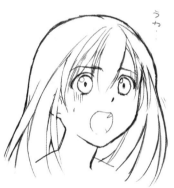

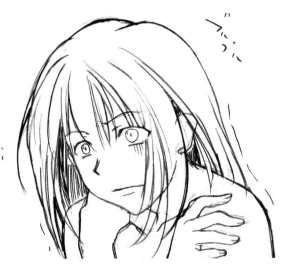

"Gasp!"

"Eeek!"

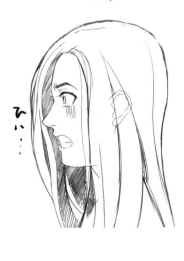

Rattled

A shock is often naturally followed by feeling shaken. Try to visualize your character's turmoil and discomfort as you draw these flustered expressions.

A younger character's shaken expression resembles fear in many ways. Widen those eyes and let his mouth hang open clumsily. Add some wobbly motion lines to illustrate shakes and shivers.

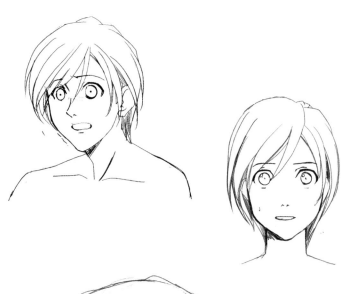

In an extreme case, even a mature character can grow panicked and lose control of his facial expression. His eyebrows drift upward and his eyes widen. His mouth hangs half-open because he's forgotten to close it!

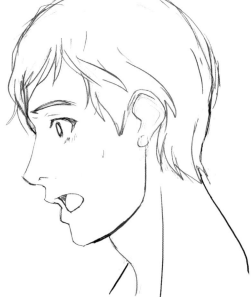

When characters are rattled, you can also show them attempting to calm themselves down. Some people's faces stay surprisingly smooth after a shock, especially considering what they've just been through!

You can still show a range of reactions in your mature characters without getting melodramatic. Try expressing their shaken state in different ways than just their facial expression—for example, draw their hand trembling as they try to sip a drink.

5.16 *Crying*

Go all out and let your characters have a good cry! Show how their expressions shift and change as they release their powerful emotions.

Wiping away tears with your arm can show your childish side. Draw your characters' eyes squeezed tight and mouths open wide with a wail. Try a few expressions where they're voiceless with shock and grief.

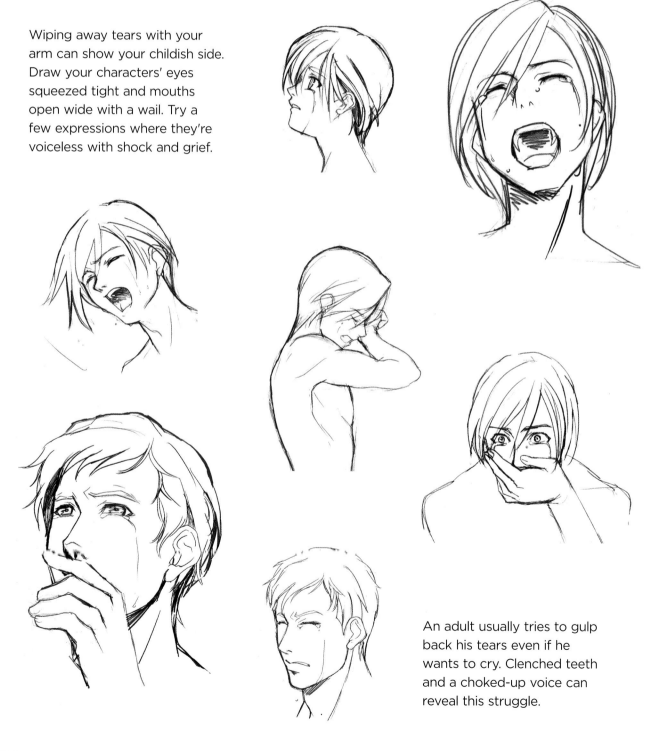

An adult usually tries to gulp back his tears even if he wants to cry. Clenched teeth and a choked-up voice can reveal this struggle.

"Nooo!"

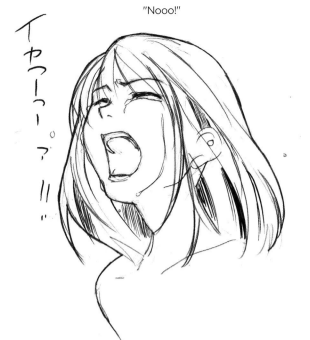

Overreaction works well for a younger character. Close her eyes, open her mouth up wide and imagine her howl bursting outward. Make sure to show the curve of her cheek as you draw tears streaming down.

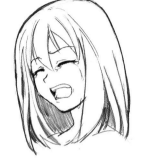

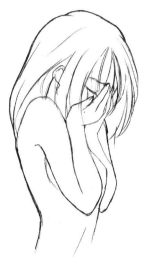

A more mature weep often shows wistfulness. The effort she puts into fighting back her sobs expresses the depth of her sorrow.

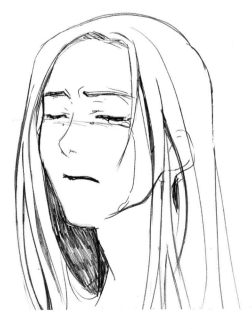

5.17 Panicked

Let's draw some frantic expressions. Try to portray your characters losing their peace of mind without losing your own!

"Sweat, sweat"

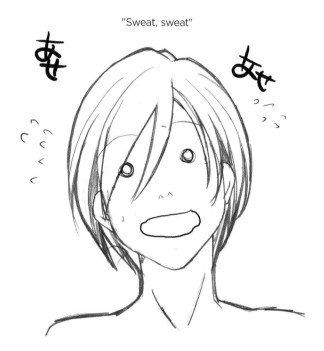

Cartoony gag faces can work great for younger characters. Big blank eyes and a wobbly mouth read panic loud and clear. When he realizes he's made a huge mistake, you can show his embarrassment with a bright blush.

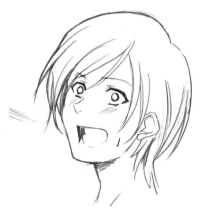

These expressions have a real sense of crisis to them, like he's witnessing an accident or really screwed up at his job. Shifty, unsteady eyes and sweat dripping down the face work well here.

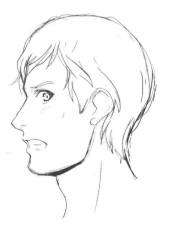

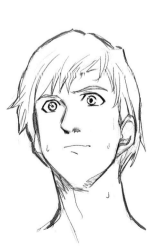

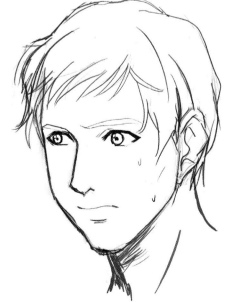

There can be a lot of variation between a humorous look and a serious panic. Try adding different combinations of flying drops of sweat, sound effects, question marks or shaky motion lines.

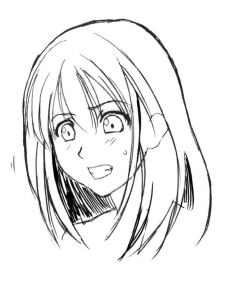

"Gasp!"

"Nooo!"

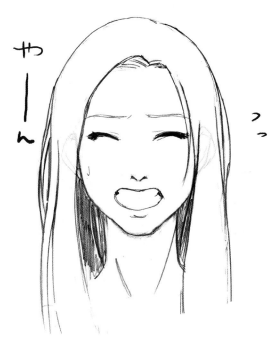

People react quite differently when they realize they've made a mistake. Choose an expression of panic that best fits the situation.

Frustrated

No matter how hard you try, sometimes you fall short and lose big! How many ways can you draw one person's frustration?

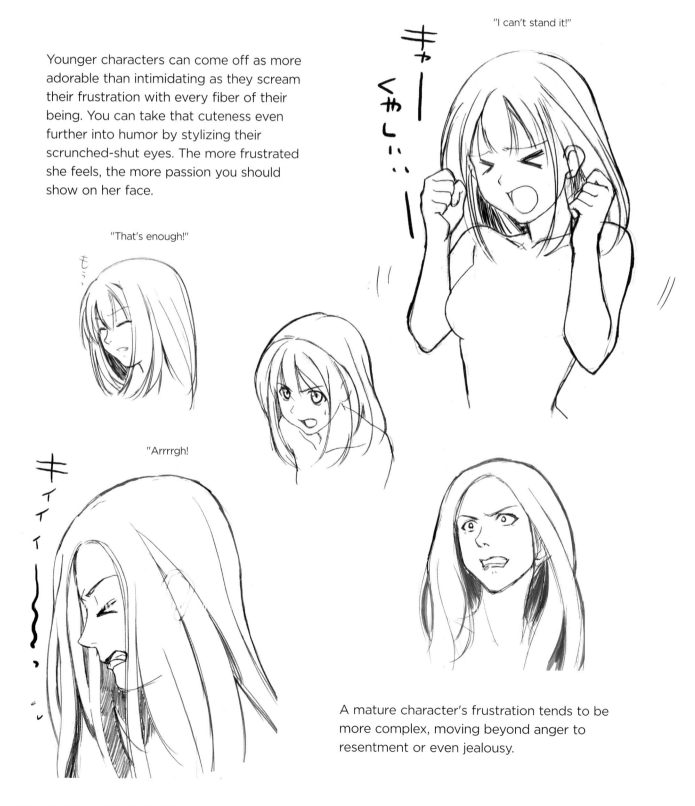

Younger characters can come off as more adorable than intimidating as they scream their frustration with every fiber of their being. You can take that cuteness even further into humor by stylizing their scrunched-shut eyes. The more frustrated she feels, the more passion you should show on her face.

"I can't stand it!"

"That's enough!"

"Arrrrgh!

A mature character's frustration tends to be more complex, moving beyond anger to resentment or even jealousy.

"Arrrrgh!

Clenched teeth and a fixed gaze come in handy here once again! If you want to express uncontrollable rage, try some cartoony puffs of steam shooting off his head.

"Clench"

Some adults show their frustration through silence rather than action. For a classic expression of defeat, draw a blank face with tears welling at the corners of the eyes.

"No!"

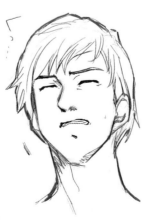

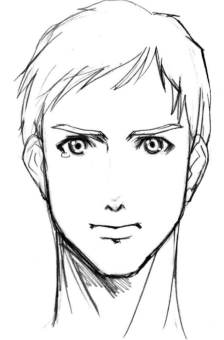

5.19 *Sulking*

Sulking expressions often arise from a place of vulnerability. Try to get at the underlying emotions beneath your character's pouty face.

For a youthful sulky look, try puffing up the cheeks or sticking out the tongue.

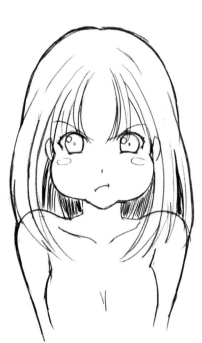

"Pfft"

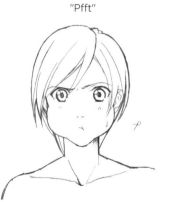

Adults often indicate their sulkiness by looking away or closing their mouth firmly.

Irritated

These characters are all mildly annoyed. They may be physically uncomfortable, or they might be bothered by another character's behavior.

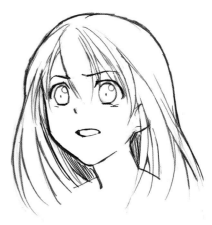

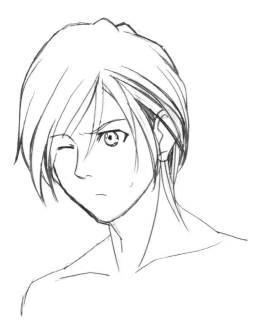

Keep the mental and physical cause of their discomfort in mind as you draw—maybe they're being hit in the face with strong sunlight (don't forget the shadows!). Take care to define the muscles around their twisting eyebrows.

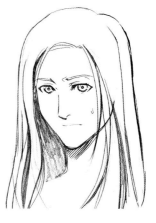

"Hmmm"

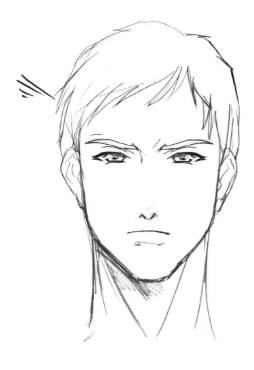

Here are some adults with contorted faces. They express their irritation with a combination of anger and exasperation.

Smirking

The amount of cruelty in a smirk varies depending on the personality of your character. These mocking smiles are often the favorite expression of strong-minded characters like anti-heroes.

"Aha!"

"Ha."

Crossed arms express his desire to dominate or bully the person he's talking to.

A younger character's smirk usually has an air of innocence. Try capturing this with cutely squinted eyes and a small smile.

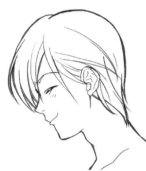

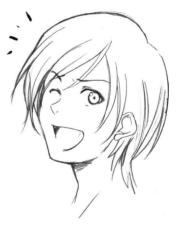

"Smirk"

Bringing one eyebrow up skeptically can make the look more teasing than cruel.

Let's draw a bold, queen bee kind of smirk. If we draw her from below, we emphasize her superiority and power, making her smile even more intimidating. Think arrogance!

"Fool"

"Smirk"

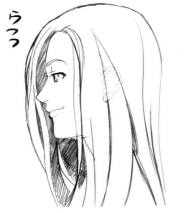

"Chuckle"

"Giggle"

For a mature smirk, a bit of enjoyment in the situation can add realism. As you draw, imagine that she's looking at the person she's talking to with detached amusement.

Suffering

Pain is one of the easiest emotions to convey because the face changes dramatically—incorporate clenched jaws and furrowed eyebrows. Pain can also be expressed through details such as labored breathing, sweat and tears.

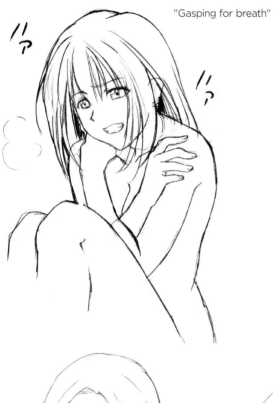

"Gasping for breath"

Draw your character hunched over in pain. Since she's clenching her teeth and breathing through her nose, draw her breath coming out in big puffs.

"Ouch!"

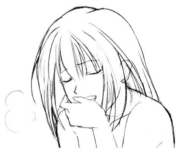

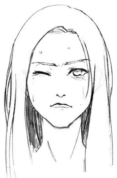

These examples, from left to right, show increasing pain, starting with bearable suffering and moving on to a stronger pain that contorts the face. In the far right picture, she can't take it any more and screams aloud with agony! Notice how her sweating and breathing increase in intensity with the level of her pain.

Show their suffering in the lines of their face. Clench their teeth, scrunch their eyebrows together and let them scream!

"Ouch!"

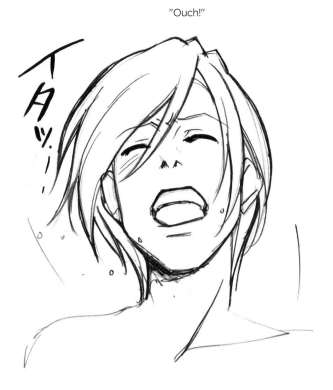

"Waaah!"

"Gasping for breath"

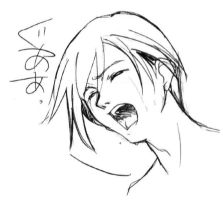

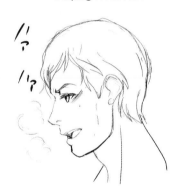

"Agh!"

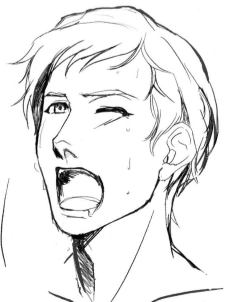

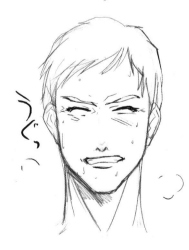

Spiteful

A real malicious expression is essential for any style of comics!
It's all about the eyes.

Here's a sly expression with a bit of impishness.
Notice how sharp and focused her eyes are. Draw
the corners of her eyes slanting upward, as well
as the edge of her mouth. You want to make her
look like she's plotting something.

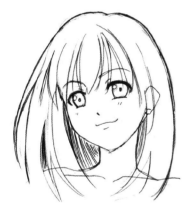

"Evil grin"

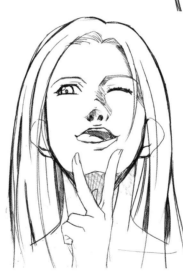

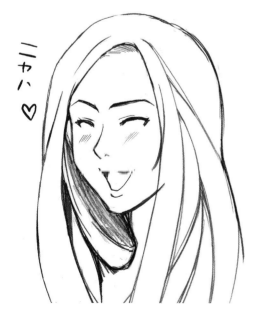

"Evil grin"

A sense of naughtiness goes well with younger characters. You can give his spitefulness a playful feel by showing him licking his lips or drawing his eyes cartoonishly.

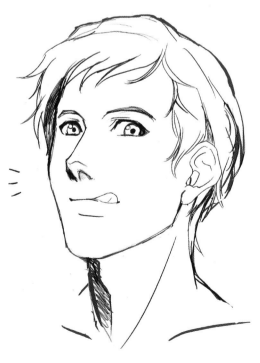

An adult's spiteful face can be comical too. Amp up the evil with a literal devilish look—try some fangs and pointy ears!

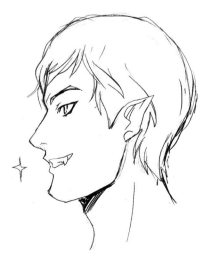

Annoyed

A similar emotion to irritation, annoyance is often characterized by scrunched eyes and clenched teeth. Express annoyance through body language, with crossed arms and hands thrown in the air.

In manga, this symbol references a pulsing vein popping to underscore being annoyed or angry.

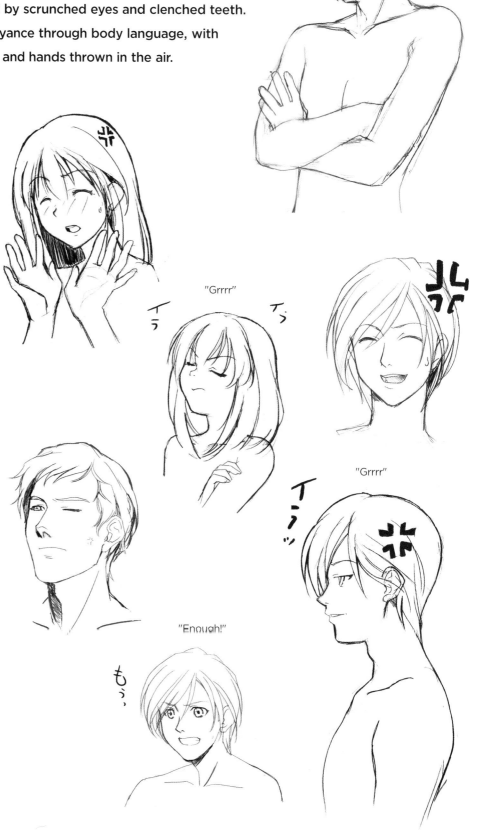

"Grrrr"

"Grrrr"

"Grrrr"

"Enough!"

Distraught

5.25

You can't get anything straight in your head when you're distraught.
Let your character show some real distress when they get so
confused that they can't focus anymore, even if they want to!

Scrunch the eyes closed, knit the brows together and open the mouth to express the character's frustration.

"That's enough!"

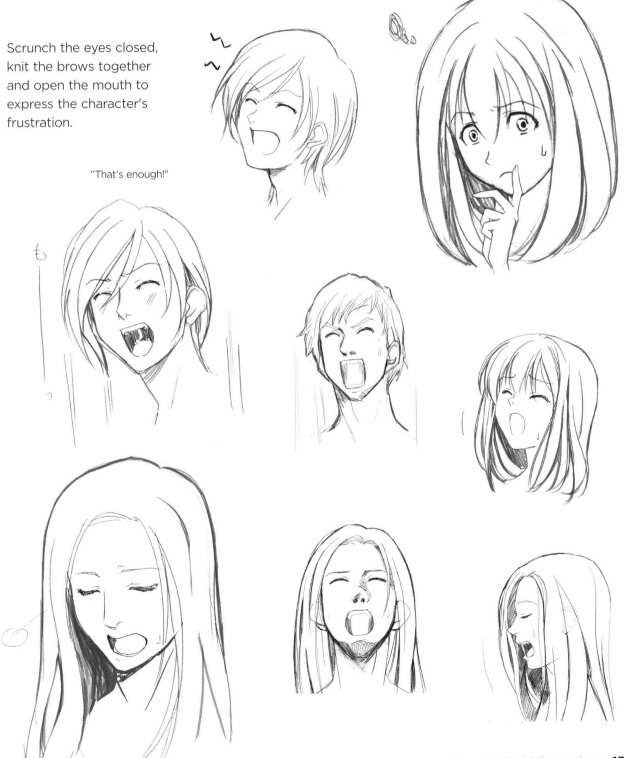

5.26 *Overconfident*

Draw these powerful expressions with dramatic poses pumping clenched fists!

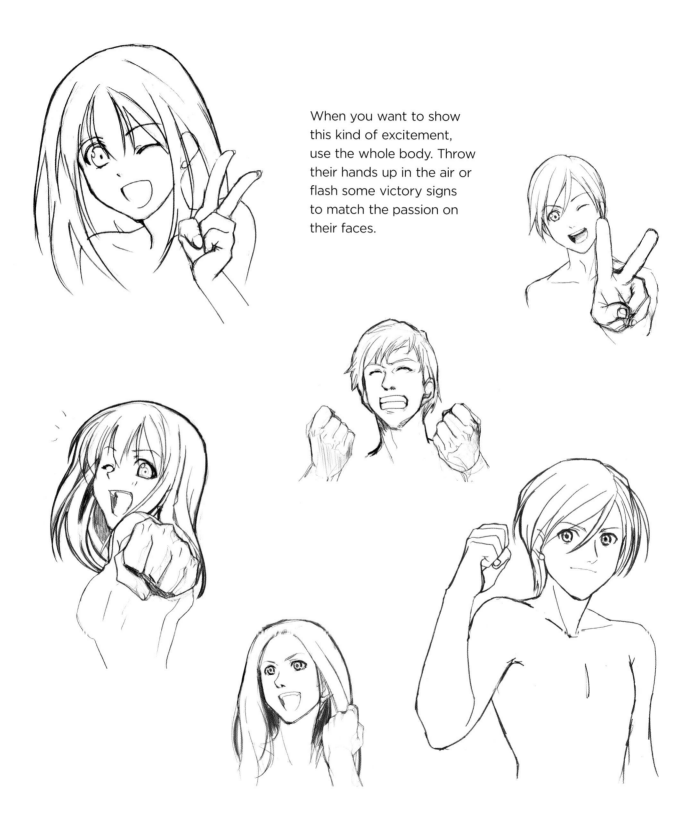

When you want to show this kind of excitement, use the whole body. Throw their hands up in the air or flash some victory signs to match the passion on their faces.

Forcing a Smile

Sometimes a character will put on a happy face to cover up their true emotions. This reaction is common when trying to hide embarrassment or anger.

These characters are hiding their authentic feelings with a forced smile. Blushing cheeks and drops of sweat reveal their inner emotions.

"I see"

"Ha ha!"

Searching for Something

Ever misplace your favorite pen and then send yourself into a panic as you rip your desk apart? Let's draw that.

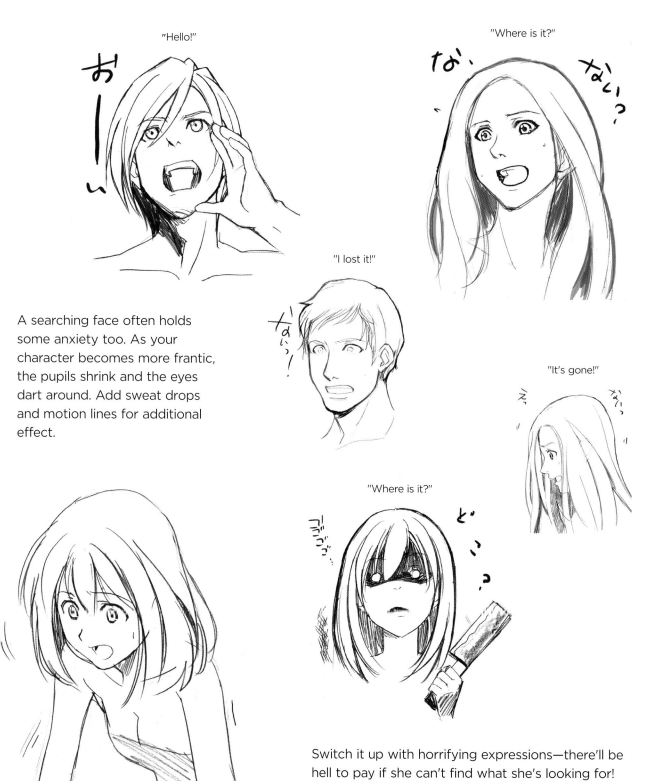

"Hello!"

"Where is it?"

"I lost it!"

A searching face often holds some anxiety too. As your character becomes more frantic, the pupils shrink and the eyes dart around. Add sweat drops and motion lines for additional effect.

"It's gone!"

"Where is it?"

Switch it up with horrifying expressions—there'll be hell to pay if she can't find what she's looking for!

Scaring Someone

Ever jump out at someone and scream to purposely scare them? When drawing this action, show the character shouting, making noises and using their hands.

Some characters are spooky due their expressions alone! Shadows and shading can really emphasize a frightening look.

"Boo!"

"Boo!"

If you push these expressions over the top, they'll quickly become comedic.

Confiding in Someone

These nuanced expressions of vulnerability and emotional turmoil are usually only shared with close friends and family.

Draw your characters looking up and blushing as they confide in someone. This expression can be very endearing!

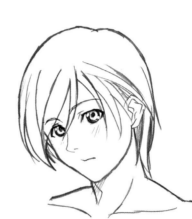

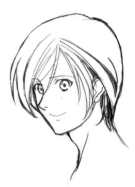

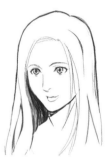

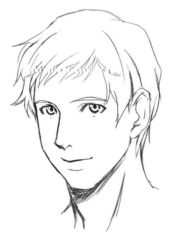

These faces all effectively tell us something with just the eyes.

"No no no!"

He's trying to change someone's mind by throwing a fit! He'd probably only act this way around someone he's close to.

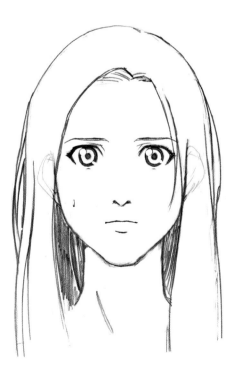

A more solemn face can express reluctance or melancholy. When characters make themselves vulnerable to others, they can open their hearts and share emotions they might otherwise keep hidden.

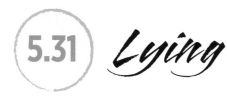

5.31 Lying

Now we'll explore the expressions of people being untruthful. Are your characters purposely spinning boldfaced lies, or are they merely teasing?

For serious deception, give them glassy eyes with extra sparkle. Push up their bottom eyelids to turn their smile into a slight smirk. For a gentler or teasing falsehood, give their face a bit more warmth and arch the eyebrows.

"Smile"

"Smirk"

"Grin"

"He he"

"Smirk"

"Smile"

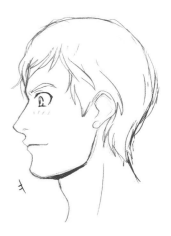

5.32 Pretending to Cry

Crocodile tears are a tried-and-true method for getting what you want.

"You caught me?"

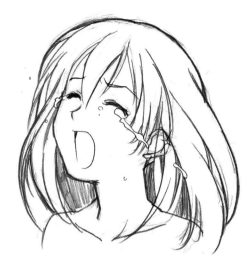

Try bringing an element of humor to your insincere young characters.

"Crying"

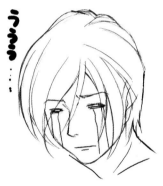

"Sob"

You can also make an adult's insincere expressions less malevolent by adding some comical elements, like exaggerated, cartoony eyes or a playfully stuck-out tongue.

Getting into Arguments

Pleading

This expression is heavy with unspoken emotion. Pull the chin in and make the character communicate with the eyes.

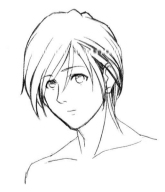

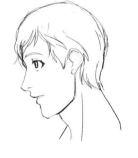

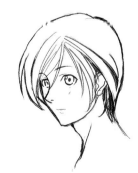

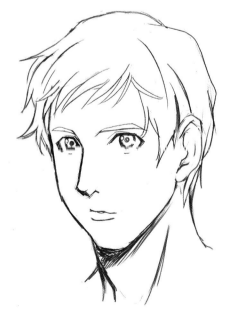

"No!"

Refusing

When conveying "No!" with facial expressions, keep in mind whether your character's anger is serious or in jest.

"No!"

"No!"

"No!"

"No!"

Let faces show the force of their "No!"

"Nu-uh."

"No!"

"Pshaaaww!"

Scolding

When youthful characters rebuke others, they'll often place the blame squarely on one person with the use of a dramatically pointed finger. Draw their face and eyes shining with righteous fury!

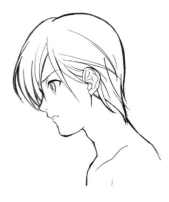

Adults often hide their disappointment or anger under a stern expression. They may calmly condemn the person in question, and then attempt to provoke them into soul-searching with an intense, silent stare.

"No!"

"Come on, really!"

Admitting Defeat

Try a good, heavy, done-with-it-all sigh.

"No way!"

These expressions get across how fed up a character is with an impossible or hopeless situation. Hand gestures can really bring these to life!

5.34 *Physical Fighting*

At some point in your story, an argument might escalate into a fist fight. Try these battered and bruised expressions when your character is on the receiving end of a beating.

"Whack!"

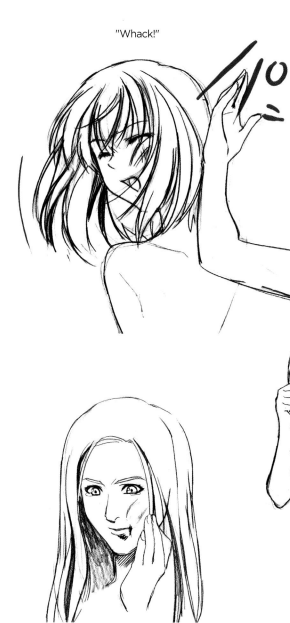

Pay attention to the way the hair moves when a character is struck or punched.

"Crack"

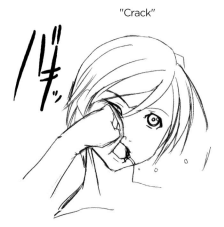

"Hacking cough"

After your character has suffered a beating, draw their face with a sense of defeat and tragedy. Showing the whites of the eyes can help create a vacant expression.

Chapter 6

Color Illustration

So far, we've been focusing on drawings rendered only in black and white. In this chapter, we'll discuss how to transform your line art into full color digital illustrations.

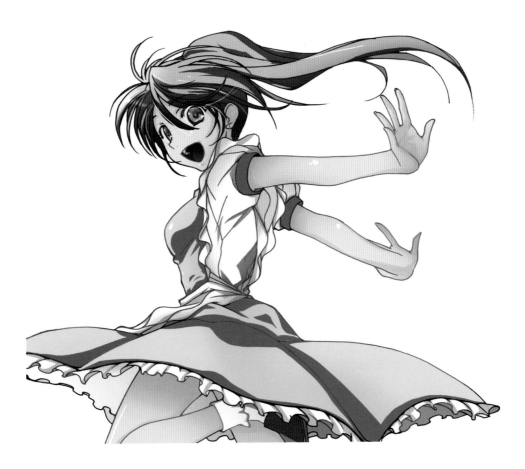

From Roughs to Line Art

The process of digitally coloring an illustration starts with the creation of the drawing itself. Let's begin with a rough sketch of a happy-go-lucky character.

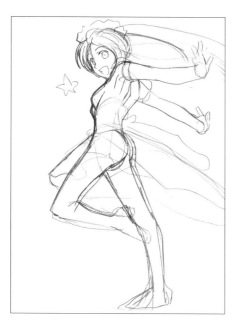

Rough Draft

1. Start off with some loose sketches as you plan out what you want to draw. Decide how large you want your illustration to be and sketch a rough at that size. Since we're drawing a joyful character, let's give her a dynamic leaping pose full of energy. Draw her body shape before you draw her clothes on top. You can use basic computer paper and your favorite pen or pencil for your first loose sketches.

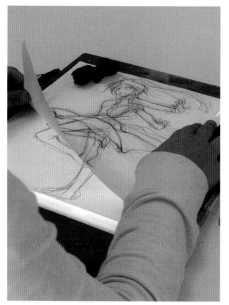

2. Your paper will get damaged if you keep drawing, erasing, and redrawing again and again. If it becomes torn or wrinkled, trace the image onto a new page by using a light box (or even just a bright window).

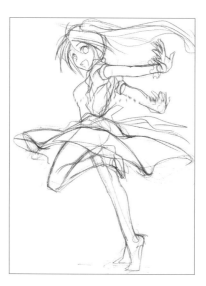

3. Finish up your rough sketch, correcting any anatomy issues.

Ink Your Sketch

1. Clear line art will make coloring much easier, so the next step is to ink your sketch. Place the sketch on top of a light box and cover it with a nice thick drawing paper, like Bristol. Just make sure the paper is not too heavy, or the sketch won't show through. Now take a pen, nib or brush and start inking. Make sure to connect your lines as this will allow the drawing to scan clearly.

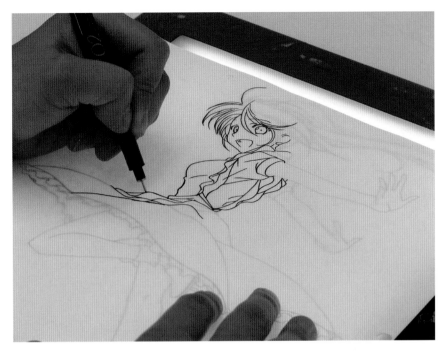

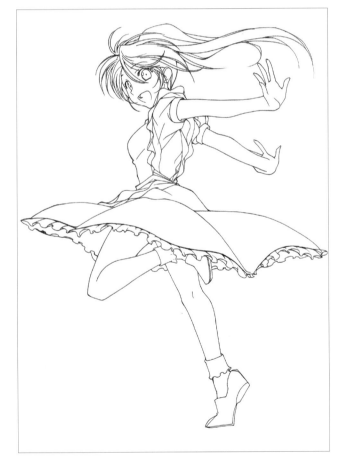

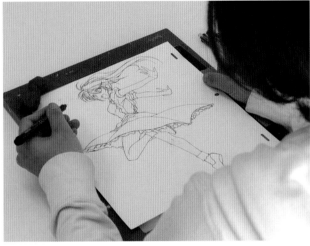

2. Once the line drawing is complete, review it and fix any stray lines or smudges with correction fluid.

Scanning Line Art

You'll need a scanner and art editing software for the next steps. In this book, we use Photoshop for digitally adding color.

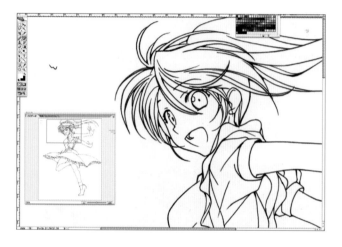

Scan and Save the Drawing

1. Scan the drawing into Photoshop by using the File tab and selecting Import.

2. Before scanning, check your settings. Scan the image in full color with a resolution of 350 dpi or higher.

3. Save the scanned drawing as a TIF file.

Our scanned and imported image before editing with Levels.

Edit Your Scan

Bits of dust and eraser rubbings often show up in the scan. You can clean these up using the Photoshop Levels function (Command + L for Mac or Ctrl + L for PC). Get a feel for this tool by first adjusting the three sliders to control the darkest and lightest tones in your picture, as well as the midtones. Then make the white of the paper brighter and brighter, and the black of the line art darker and darker, until the grays vanish but your inked details don't. If you can still see some dust or dirt around, clean it up with the Eraser (E) or Brush/Pen (B).

Our line art all tidied up with Levels.

Image after applying the Levels function.

If you are still seeing pesky grays around your line art, you can also use the Threshold tool under Adjustments to remove any remaining marks.

Fine Line Edits

Next, take a minute to edit the line art itself using the Eraser. Check for broken lines or places where shapes overlap messily. Even small edits, like sharpening lines between strands of hair, will enhance the image quality.

Isolating Line Art and Adding Color

To prepare our file for coloring, we first need to isolate the art using the Channels function in Photoshop. Then, we'll be ready to add in basic colors and shadows.

Isolating Line Art

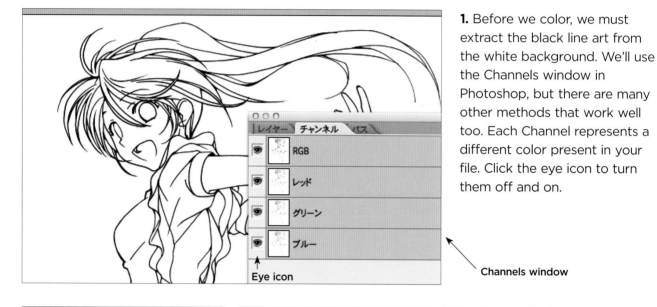

1. Before we color, we must extract the black line art from the white background. We'll use the Channels window in Photoshop, but there are many other methods that work well too. Each Channel represents a different color present in your file. Click the eye icon to turn them off and on.

Channels window

Eye icon

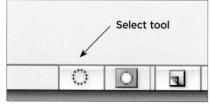

Select tool

2. Click on your image, and then click the dotted Select tool at the bottom of the Channels window. You can also use the Magic Wand (W) if you like.

3. Photoshop will helpfully select only the white part of your image. Notice the flashing dots outlining your drawing.

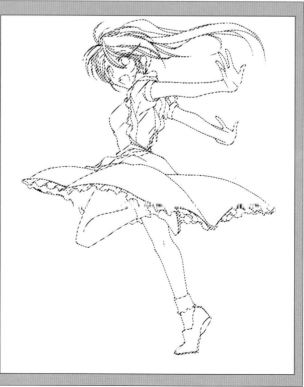

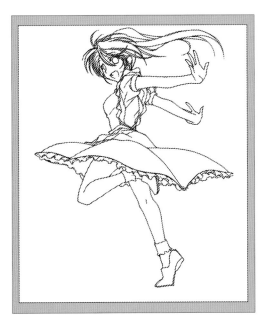

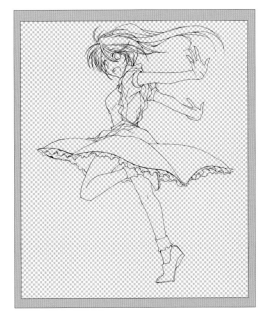

4. Select the inverse of the white background, which is the black line art. Use the following keys to do this: Shift + Ctrl + I for PC or Shift + Command + I for Mac. Next, copy it by using Ctrl + C for PC or Command + C for Mac.

Adding Base Colors

5. Make a new layer and paste your line art to it (Ctrl + V for PC or Command + V for Mac). You can also use the Paint Bucket (G) to fill your dotted selection. Label this layer as Line Art and delete the original layer underneath so you're not seeing double.

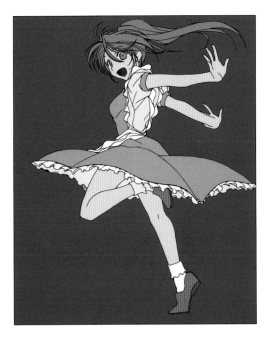

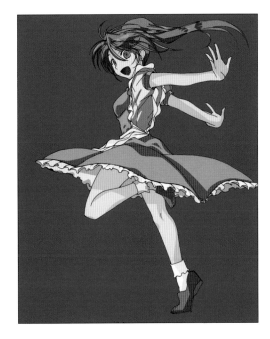

1. Now the line is transparent, and it's time to lay in some placeholder "flats," or base colors, on a new layer underneath. Use the Fill/Paint Bucket (with the All Layers and Contiguous options checked), and fill in any troublesome gaps with the Pen. Flatting can be a bit tedious, but your patience will pay off later when you can adjust your final colors with ease.

2. After you've completed your flats, you can make another layer to add basic shadow. Pick a direction for your picture's light source (here it's above and to the left) and block in the shadows accordingly. Don't forget that her hair and clothes will leave shadows too.

6.4 Shading

It's time to add details and shading that will bring your drawing to life. Apply color details to her skin, hair and clothing for greater depth and realism.

As we move on to shading her clothes and hair, you might find it helpful to open new layers for each separate element. That way, you can color and edit freely without worrying about altering the work you've already done. Just remember that the more layers you add, the larger your file will grow and the slower your computer will run.

Shading Skin, Hair and Clothes

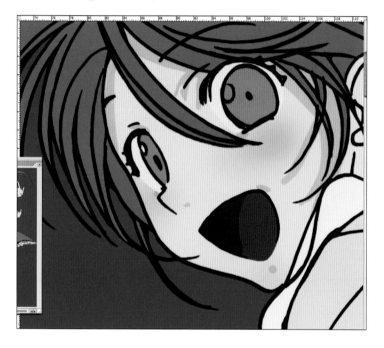

1. Have some fun with your painting tools! Use Brush for soft-edge color and Pencil for harder edges. To achieve a soft blush like in the illustration at left, switch your Brush's settings to an airbrush and turn the size up, up, up! Pay close attention to how her eyes are set into her face—where do they curve out and where do they sink in? Work with your line art to subtly sculpt your illustration through color and shade.

2. Here's a close-up of her palm. Notice how we've used color of different values and textures to bring more detail to the form of her hand. The inside of her fingers and the hollow of her palm are all cast in a midtone pink shadow with dark pink details, while the tops of her fingers and the entire heel of her thumb catch the light source. Add a touch of that dark pink to her fingertips for extra realism (and cuteness!).

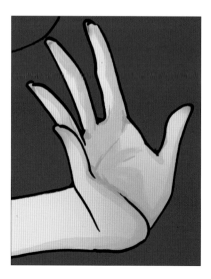

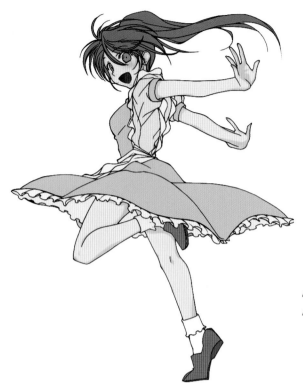

Here she is with her skin fully shaded.
Let's do her hair next!

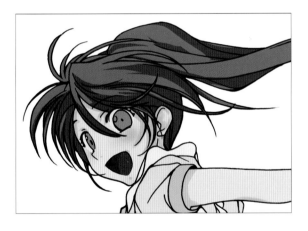

3. It's easy to overshade the hair and lose detail. You can achieve nice midtones by occasionally erasing shade as you paint. Then you'll be ready to add final highlights to the hair later.

4. Next, let's shade her clothes, starting with the dress. As you shade, notice how the clothing creases and folds around her body. Since this girl is swinging her arms back, the fabric of her blouse and dress should crease under her arm. Make sure to add shading to define the curve of her breasts and torso.

5. Here's the dress with finished shading. You can create depth and volume in her billowing skirt with large shadows. The strong contrast between the light value of her skirt and the dark value of its shadowy folds really brings her outfit to life.

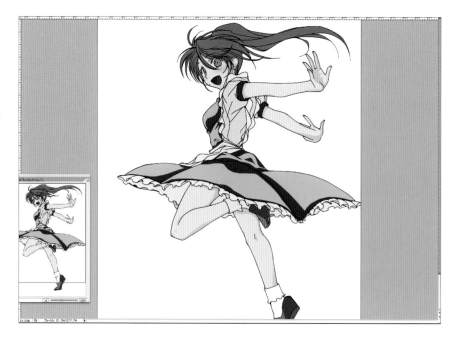

Adding More Details

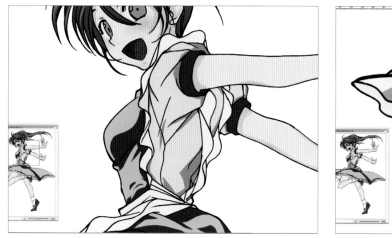

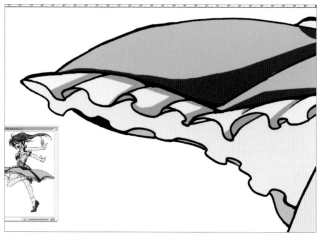

1. Time for her blouse. Don't forget about how the movement of her arms affects the wrinkles and shadows of the shirt. For realistic shadows, pay attention to the direction of the light source. In this case, her whole back could be cast in shadow, but instead we've made a style decision to keep her blouse looking bright.

2. Slip in some shading to pump up the volume of those ruffles. Even though the line art has already done the work of defining each fold, you can use shadows to develop their shape even further. We've chosen not to shade the underside of her skirt this time.

3. Finish by giving her shoes and socks a bit of shading too. Take a moment to zoom out and look at the entire image. Does your shading look balanced? Are all the shadows cast in the same direction?

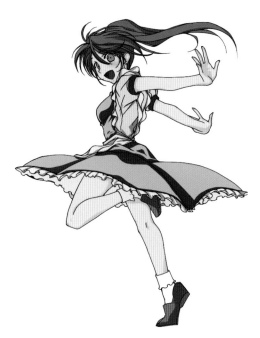

COLORING EYES

The windows to the soul deserve some extra attention! Follow these steps to create expressive eyes:

1. Start with the darkest color, and paint the pupil. Then softly brush in the gradated shadow cast by her upper eyelid and outline her iris. Don't forget that the eyeball is a sphere.

2. Adjust the colors until you like the way they look.

3. Time for lighter tones. Set a new layer on "Linear Dodge," and play around with the resulting shimmery effect. Try adding a streak of light on the bottom of her iris and softer light on the top. Erase a bit in the middle to amp up the shininess and roundness of the eye.

4. Return to your coloring layer and add a highlight.

5. For a glossy finishing touch, you can accentuate your highlight with a little more white set at a lower opacity. So dewy!

Finishing Touches

We're almost done! Now it's time to tweak those colors and dab in a few extra highlights or touches of color.

Completing Colors

Now is the time to make any final color adjustments until you feel satisfied with the look and mood of your piece.

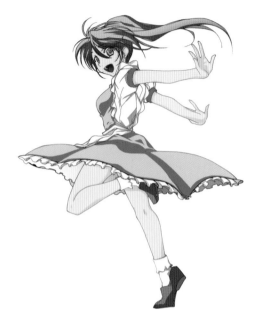

Coloring Line Art

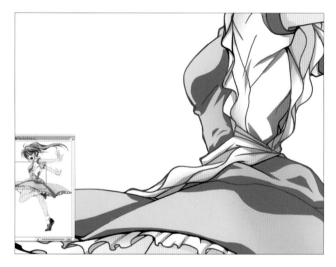

1. Let's kick things up a notch and change the color of the line art itself. Head over to your line art layer and click the "Lock Transparency" setting on the layer controls.

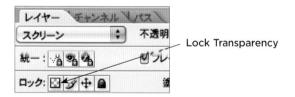

Lock Transparency

2. By clicking on this checkered button, we've made it impossible to paint on any transparent areas. That means we can paint away at the line art without worry. Try to match the line art to the colors surrounding it without losing detail, and use your Brush for gentle transitions.

3. Here's our colored line art isolated. Notice how we've left the line art of her shoes black, but painted her skin peachy and her skirt blue.

Final Edits

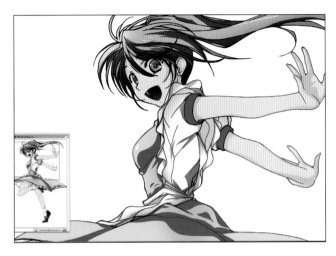

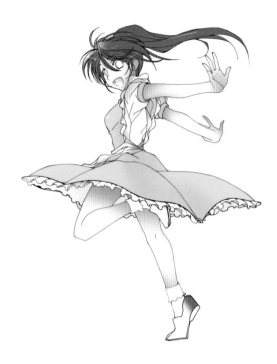

Let's go just one step further with the airbrush. Open up a new layer (as shown on the right), and add some light gradients on her skin, clothes and hair to accentuate the shadows. Change the layer setting to Multiply and watch your illustration pop.

Highlights

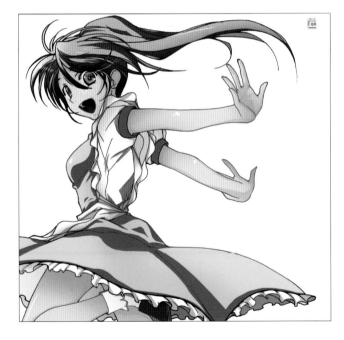

Create movement by adding a few highlights on her mouth, elbows, knees and hair.

Finish!

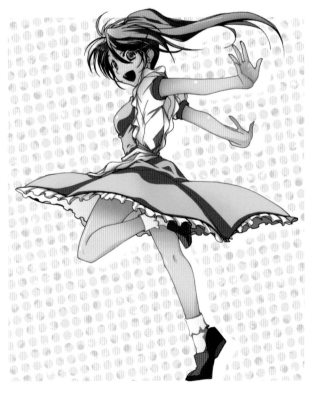

Add a background and finish!

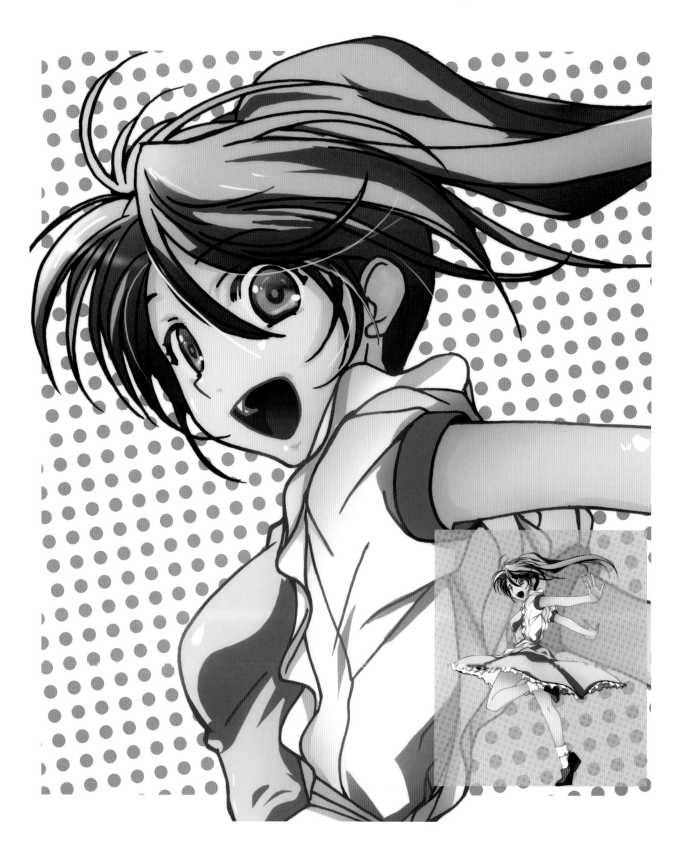

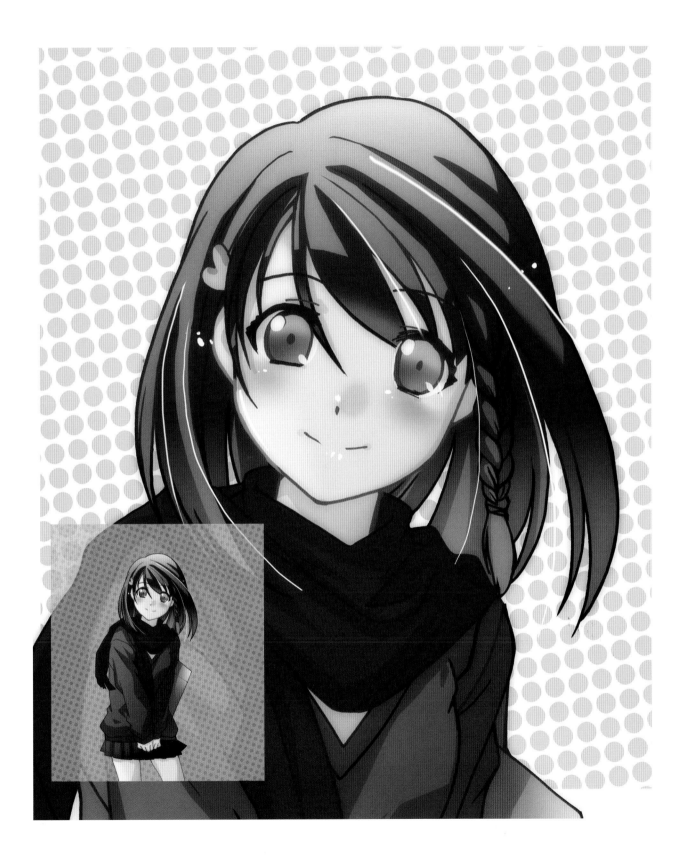

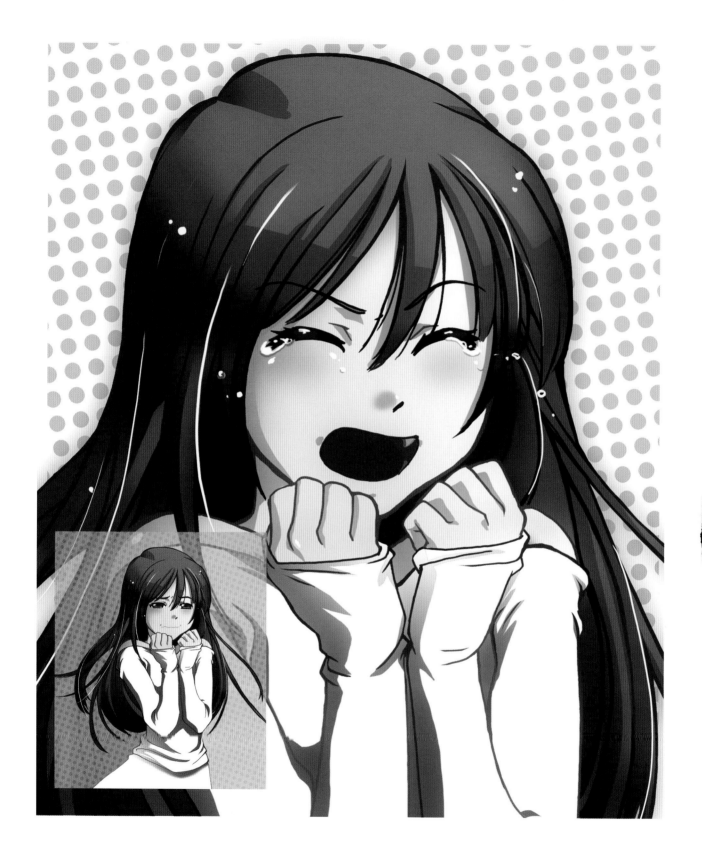

About the Author

Aya Hosoi is a self-taught freelance illustrator.
She works in anime and game production.
In addition, she also designs covers for CDs
and other media.